MASTERPIECES

FROM THE
LOS ANGELES COUNTY
MUSEUM OF ART
COLLECTION

MASTERPIECES

LOS ANGELES COUNTY
MUSEUM OF ART

FROM THE
LOS ANGELES COUNTY
MUSEUM OF ART
COLLECTION

BY LORNA PRICE

Published by Los Angeles County Museum of Art
5905 Wilshire Boulevard
Los Angeles, California 90036

Produced by Ed Marquand Book Design
506 Second Avenue, Suite 1201
Seattle, Washington 98104

Library of Congress Cataloging-in-Publication Data

Los Angeles County Museum of Art.
 Masterpieces from the Los Angeles County Museum of Art collection.
 Includes index.
 1. Art—California—Los Angeles—Catalogs.
2. Los Angeles County Museum of Art—Catalogs.
I. Price, Lorna. II. Title.
N582.L7A647 1988 708.194'94 87-36685
ISBN 0-87587-146-1

Printed in Japan

CONTENTS

FOREWORD

The 126 masterpieces illustrated and discussed in this handbook will help to introduce to the general public the permanent collection of the Los Angeles County Museum of Art. The aims of this publication are simple: to assist visitors during their walks through the galleries, to introduce various cultures and artistic periods spanning many centuries, to creatively juxtapose the past and the present, to broaden visitors' perceptions of fine art and enhance the understanding of human creativity in its many forms, and to make the museum a source of learning and a place of enjoyment.

For this publication the curatorial staff selected significant and interesting acquisitions that best reflect the museum's long tradition of serious collecting. This handbook will also serve discerning specialists, scholars, librarians, and students as a tool and a visual reminder that the museum holds collections of great strength and art-historical importance.

The works illustrated have been selected from the more than 250,000 objects that constitute the museum's holdings. They represent the breadth and scope of collections in each of the museum's ten departments devoted to specific art-historical fields: American Art, Ancient and Islamic Art, Costumes and Textiles, Decorative Arts, European Painting and Sculpture, Far Eastern Art, Indian and Southeast Asian Art, Photography, Prints and Drawings, and Twentieth-Century Art.

The handbook reveals the care with which the program of acquisition has been planned and thoughtfully carried out from the museum's early years to the present day. The long-range vision and dedication of the trustees, donors, and patrons and the energies of the professional staff have enabled the Los Angeles County Museum of Art to attain notable levels of excellence in its collections.

This handbook is the third for which there has been a need in less than twenty-five years. The first was published on the occasion of the museum's opening on the Hancock Park site in 1965 as an entity independent of the old Museum of Science, History, and Art. The second was published in 1977 to celebrate more than a decade of striking growth in the collections. The present handbook acknowledges this continuing growth and the further development of museum facilities in response to an active and ever-broader patronage.

Each illustrated object in this book is accompanied by a brief essay explaining its art-historical and cultural value and aesthetic merit. The captioning states artist, origin, title of the work, its

medium and dimensions, donors, and the museum accession number, whose first two digits indicate the year in which the work was acquired. This chronological notation reveals the steady growth of our artistic patrimony.

Recent years have witnessed a succession of expansions of the museum. Many departments have been reorganized, strengthened, and enlarged. The old galleries of the Ahmanson and Hammer buildings have been refurbished, restructured, and renovated. The Robert O. Anderson Building opened in November 1986, a handsome and spacious architectural monument. The new Pavilion for Japanese Art opened in 1988 to house the museum's extensive holdings in that area as well as to provide space for changing exhibitions. It will eventually house the Shin'enkan Collection of Mr. and Mrs. Joe D. Price.

Soon the museum will celebrate its twenty-fifth anniversary in the Hancock Park site. Its spectacular growth during more than two decades was nurtured by increasing civic pride and public interest in art and culture. The strength of this institution is vital proof of the ascendancy of Los Angeles as an art and cultural center, renowned in the West, nationally, and internationally.

The professional staff of the Los Angeles County Museum of Art has contributed to this auspicious cultural growth with a vigorous commitment to collect and enrich the museum's holdings. Despite unprecedented competition in world art markets and ever-rising standards of collecting, generous donations continue to enrich these galleries.

This illustrated handbook is an expression of the museum's obligation to the public as well as a promise to patrons and donors to make the collections better known and to present the galleries as a center for education and a place for contemplation and quiet study.

The trustees, the director, and the museum staff extend to the public a cordial invitation to visit the many galleries and other facilities of the Los Angeles County Museum of Art. Here all may, through art, trace the growth of human cultural consciousness from prehistory to the present and come to understand the ways in which that art illuminates the greatest aspirations of humankind.

Earl A. Powell III
Director
Los Angeles County Museum of Art

AMERICAN ART

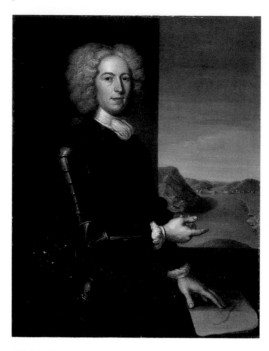

JOHN SMIBERT
Scotland, 1688-1751, active in the United States
Portrait of Major General Paul Mascarene, 1729
Oil on canvas, 40½ × 31⅜ in. (102.9 × 80.3 cm)
Purchased with funds provided by the Mr. and Mrs. William
Preston Harrison Collection, the Charles H. Quinn bequest,
Eli Harvey, and other donors 78.8

John Smibert divided his early career between Edinburgh, his birth-place, and London, where he variously studied art, worked as a plasterer, painted houses and coaches, and eventually set up as a portrait painter and copyist. He arrived in Italy in 1717, copied master paintings in Florence and Rome for his patron Cosimo III de' Medici, and then returned to London. By 1722 he had a studio there and was considered a leading portraitist.

Smibert arrived in the American colonies in 1728, attracted by cli-mate, opportunity, and the promise of employment in a visionary utopian colony to be established in the Bermudas. It failed to materialize, but he remained, the first fully trained artist in the colonies. He established a highly successful portrait practice in Boston.

Smibert's painting of then-Major Paul Mascarene is in the grand tradition of European military portraiture and includes the customary although anachronistic suit of armor. Smibert's skill in showing the play of light on its surface, as well as the firm plasticity of Mascarene's figure, marks a notable stylistic advance over the flatness typical of earlier New England portraits.

Smibert composed beneath Mascarene's extended hand a still life of map and drafting instruments, symbolizing the major's profession as chief engineer of the military survey and fortification of Nova Scotia. The landscape behind Mascarene, possibly a view of the fort at Port Royal, is among the earliest actual New England landscapes and not the usual conventional garden or imaginary scene used by colonial portraitists.

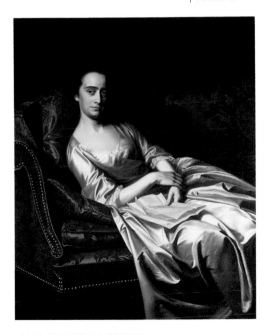

JOHN SINGLETON COPLEY
United States, 1738-1815
Portrait of a Lady, 1771
Oil on canvas, 49⅞ × 39½ in. (126.7 × 100.3 cm)
Purchased with funds provided by the American Art Council,
Anna Bing Arnold, the Patrick F. Burns bequest, the Mr. and Mrs.
William Preston Harrison Collection, David M. Koetser, the Art
Museum Council, Jo Ann and Julian Ganz, Jr., The Ahmanson
Foundation, Ray Stark, and other donors 85.2

John Singleton Copley's career is remarkable not only for his precocious talent but also because he was the first major American artist to achieve artistic maturity and success wholly through American training and experience. The son of poor Irish immigrant merchants, by age fourteen he was gaining a living in Boston with his artistic talent, and before he was twenty-one he had a successful portrait practice.

Copley's painting style matured by the 1750s. He rapidly assimilated techniques from John Smibert, John Greenwood, and Thomas Blackburn and then surpassed them, mastering an opulent illusionism, firm sculptural form, rich color, and a range of courtly conventions.

This portrait of an unknown woman displays Copley's technical virtuosity in the drapery folds and the damask-upholstered sofa. Strongly illuminated against an empty dark ground, the woman relaxes; her informal pose and direct gaze reveal Copley's concentration on her personality. Her gown, a style then worn only in private or among the family, contributes to the intimacy of the study. Copley's attention to the sitter's thoughtful expression exemplifies the somber style of his 1770s portraits, which achieved a commanding psychological as well as physical realism and stand among his greatest American-subject masterpieces.

Both Joshua Reynolds and Benjamin West urged Copley to study in England. Reluctant to leave his prosperous studio, the artist, a loyalist, remained in the colonies until 1774, when revolution seemed inevitable. After a period of travel, he settled in London, and spent the second half of his career achieving an even greater success in England.

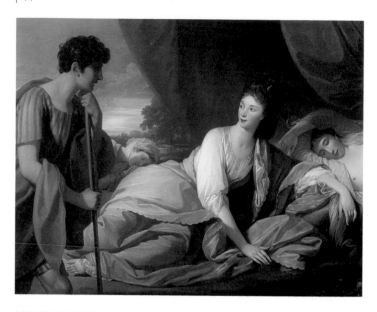

BENJAMIN WEST
United States, 1738–1820, active in England
Cymon and Iphigenia, 1773
Oil on canvas, 50×63⅛ in. (127×160.3 cm)
Purchased with funds provided by Mr. and Mrs. Reese Llewellyn
Milner, Mr. and Mrs. Byron E. Vandergrift, George C. Zachary, Jo Ann
and Julian Ganz, Jr., and Joseph T. Mendelson M.82.91

A precocious talent like his contemporary John Singleton Copley, Benjamin West was painting portraits by age fifteen. He studied art briefly at the College of Philadelphia and then painted signs and portraits. With the financial help of friends, he arrived in Italy in 1760, possibly the first American artist to study there.

In 1763 West settled permanently in England, in possession of a developed painting style, amiable manners, and letters commending his talents and giving him social entrée. On the advice of a former client, he turned from the secure living of portraiture to historical subjects. In *Death of Wolfe* (1771) he virtually revolutionized history painting by depicting protagonists in contemporary rather than classical garments.

Cymon and Iphigenia, commissioned by the second earl of Buckinghamshire, may refer to finding the ideal wife. The painting alludes to Boccaccio's tale of the rustic and graceless young Cypriot noble Cymon, who was intellectually and emotionally awakened by Iphigenia's beauty. Usually depicted asleep and nearly nude, Iphigenia may be an allegorical portrait of Buckinghamshire's second wife. The somewhat stiff neoclassical style that West introduced to England, and which marks his work in the mid-1760s, gives way here to simpler forms, richer color, and a more elegant technique. Elements of exotic costume and the natural landscape in the background prefigure the romanticism that emerged in West's work of the 1780s.

West remained popular and enormously influential until his death; his English success encouraged a generation of ambitious colonial artists to study with him.

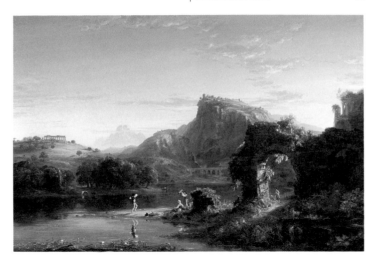

THOMAS COLE
England, 1801-48, active in the United States
L'Allegro, 1845
Oil on canvas, 32⅛ × 47⅞ in. (81.6 × 121.6 cm)
Gift of the Art Museum Council and the Michael J. Connell
Foundation M.74.53

In 1819 Thomas Cole emigrated with his family from Lancashire, England, to Steubenville, Ohio. For the next several years the young man turned his hand to wood-block cutting and wallpaper design and became an itinerant painter, but he achieved little success. He also had literary interests and occasionally published poems and stories. After 1823 his reputation as a painter spread quickly when he sold a few paintings he had placed, without much hope, in a New York shop. Starting in 1829 he toured Europe, studied in Italy, and had a studio in Rome.

In the years before his European sojourn Cole had painted from nature, observing the changing scene along the Hudson River; he also favored ideal landscapes depicting no specific location. Returning to New York in 1832, he turned to literary and allegorical subjects, sometimes painting works in thematically linked pairs. *L'Allegro* and *Il Penseroso* are two such paintings; taken together, they form a complex and allusive unity. They interpret the emotional and poetic but not literal content of the two poems by John Milton.

The simple life of peasants untainted by civilization was a prominent theme of both the Enlightenment and Romantic periods. Here it emerges pictorially in an idealized landscape drawn from Italian architectural and intellectual history. Cole's pastoral Arcadians rejoice among ruins in the long light of late afternoon. The foreground dancer's pose, modeled after the dancing satyr of Pompeii's murals, suggests pagan undertones. The ruined arches, viaducts, and bridges refer to classical antiquity.

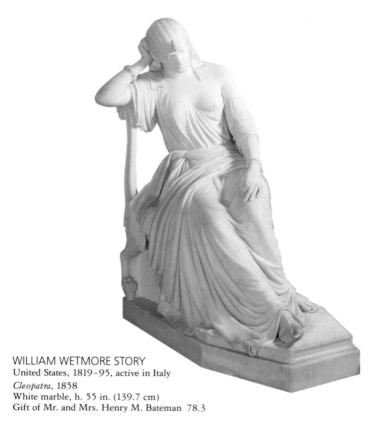

WILLIAM WETMORE STORY
United States, 1819–95, active in Italy
Cleopatra, 1858
White marble, h. 55 in. (139.7 cm)
Gift of Mr. and Mrs. Henry M. Bateman 78.3

Raised in Boston and educated at Harvard, William Wetmore Story lived at the heart of privilege. He was friendly with the most literate and gifted of American and European society, including the Brownings, W. M. Thackeray, Nathaniel Hawthorne, and James Russell Lowell. By the time Story devoted his considerable energies to sculpture, he already had had a successful law practice and had published poetry, essays, and the papers of his father, Supreme Court Justice Joseph Story. The judge's death in 1845, a subsequent commission to execute his monument, and a debilitating bout of typhoid caused Story to leave law and eventually to take up sculpture full-time. He and his family settled permanently in Rome in 1856.

With *Cleopatra* Story directed American neoclassical sculpture away from the detachment of Grecian ideals to a new romanticism and the potential for realism and psychological drama. The work established Story as the foremost American sculptor of his generation, and its dramatic power influenced the development of sculpture internationally as well as in America.

The sculpture is a study of Cleopatra's passion and despair as she contemplates the action that will lead to her fall. A brooding expression crosses her African features, her posture is slumped, and her outstretched hand fidgets tensely. The work captured the imagination of an educated audience that set great store by narrative subjects. Pope Pius IX so admired *Cleopatra* that the Roman government paid all shipping costs in order to exhibit it in 1862 at the Roman Court of the International Exposition in London, where it made Story's reputation.

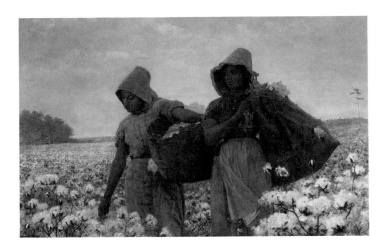

WINSLOW HOMER
United States, 1836–1910
The Cotton Pickers, 1876
Oil on canvas, 24×36⅛ in. (61×91.7 cm)
Acquisition made possible by museum trustees Robert O. Anderson,
R. Stanton Avery, B. Gerald Cantor, Edward W. Carter, Justin Dart,
Charles E. Ducommun, Mrs. F. Daniel Frost, Julian Ganz, Jr., Dr.
Armand Hammer, Harry Lenart, Dr. Franklin D. Murphy, Joan
Palevsky, Richard Sherwood, Maynard J. Toll, and Hal B. Wallis M.77.68

Between 1874 and 1876, shortly before he turned to the New England
marine images that preoccupied him for the rest of his life, Winslow
Homer traveled several times to Virginia on painting excursions. During
the final siege of the Civil War he had covered the area around Petersburg
as a correspondent-illustrator for *Harper's Magazine*. It was here that
he first made studies for a series of watercolors and paintings about the
life of rural blacks, a subject artists and writers had generally treated in a
range extending, at best, from the sentimental, melodramatic, or trivial
to the sarcastic or patronizing. Contrary to these superficial interpre-
tations, Homer now viewed the Southern black with realism, sensitivity,
and restraint. His depictions of American blacks link him with artists
such as Jules Breton and François Millet, who had portrayed European
peasant subjects with similar nobility and strength.

This painting represents the climax of Homer's early figural style.
Viewed from a low vantage point, two powerful and majestic women fill
the canvas and dominate the composition. Homer has captured a deep
meditation in the downturned face of one, a somber reflection and yearn-
ing in the gaze of the other. When *The Cotton Pickers* was painted, some
found Homer's interest in the American black incomprehensible, but
the work was well received critically, and the artist was complimented
for having seen new possibilities in a distinctly American subject matter.

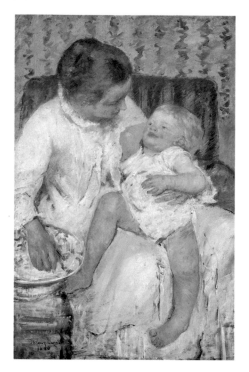

MARY CASSATT
United States, 1844-1926, active in France
Mother About to Wash Her Sleepy Child, 1880
Oil on canvas, 39⅜ × 25⅞ in. (100 × 65.7 cm)
Mrs. Fred Hathaway Bixby bequest M.62.8.14

Mary Cassatt occupies a unique place in American art. The only American painter to show work in the famed impressionist exhibitions, she gained the respect of Claude Monet, Gustave Courbet, Auguste Renoir, James McNeill Whistler, and Pierre Puvis de Chavannes, with whom she worked. Edgar Degas was her mentor and friend. Cassatt settled permanently in France in 1874 but continued to exhibit in the United States, influencing American collectors to acquire French impressionist works.

Degas invited Cassatt to exhibit in the fourth impressionist exhibition in 1879 and in many subsequent exhibitions. Reviewing her paintings in the sixth show, critic Karl Huysmans remarked that she had become "an artist who owes nothing any longer to anyone.... Composed of children, interiors, gardens ... it is a miracle how in these subjects ... Miss Cassatt has known the way to escape from the sentimentality on which most [English artists] have foundered."

In *Mother About to Wash Her Sleepy Child* a luminous and tender domesticity is Cassatt's subject, one to which she devoted nearly a third of her artistic production. Here she explores surface patterns, elements of composition she observed in Japanese prints, and the awkward naturalism of pose typical of Degas's work and an important element of the impressionist concern to catch a moment's movement or light. Cassatt had also begun to use a high-keyed palette, reflecting the impressionists' fascination with the effect of light. Intense in hue, this work reveals the interaction of white garments and flesh tones with the blues and greens of the setting. Brushwork and tints give the painting its shimmering surface.

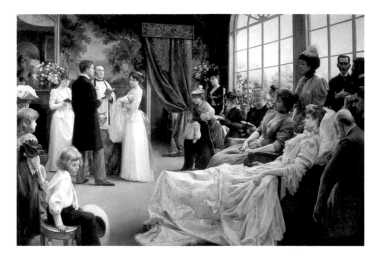

JULIUS L. STEWART
United States, 1855-1919, active in France
The Baptism, 1892
Oil on canvas, 79¼ × 118¼ in. (201.3 × 300.3 cm)
Purchased with funds provided by the Museum Acquisition Fund,
the Mr. and Mrs. William Preston Harrison Collection, Mr. and Mrs.
J. Douglas Pardee, Jo Ann and Julian Ganz, Jr , Mr. and Mrs. Charles
C. Shoemaker, Mr. and Mrs. William D. Witherspoon, Mr. and Mrs.
Thomas H. Crawford, and other donors 80.2

Julius L. Stewart's education, career, and reputation were all formed in
Europe. Son of the wealthy expatriate art collector William Stewart,
this artist had entrée into the salons of rich Americans living abroad and
their European friends. In this stratum of social privilege Stewart found
virtually all his subjects. His popularity and success continued from
1878, when he first exhibited in the Paris Salon, to the end of the cen-
tury. *The Baptism*, last of his elaborate group subjects, received acclaim
at the Berlin International Exposition. In the late 1890s Stewart made
studies of the nude outdoors, scenes of Venice, and later, depictions of
religious subjects. By the end of the decade his career began to decline,
and he received little further public or critical attention.

Initially Stewart painted single figures but soon became known for
his elaborate narrative pictures. The painstaking detail of the figures
assembled in *The Baptism* suggests particularity; the men's faces are
strongly individual, although the women's are less so. The scene was
probably inspired by a specific baptism, but the identity of the family
is unknown.

The Baptism, with its illusionism, elaborate composition, implied
narrative, and slow ceremonial pace, is a tour de force of technical skill
and a prime example of late nineteenth-century aesthetics. The richly
covered damask walls, the silk, satin, and lace trim of the elaborate
attire, and the soft, delicately rendered skin of the women and children
are as astonishing as their identity is cryptic.

JOHN SINGER SARGENT
United States, born Italy, 1856-1925
Portrait of Mrs. Edward L. Davis and Her Son, Livingston Davis, 1890
Oil on canvas, 86⅛ × 48¼ in. (218.7 × 122.5 cm)
Frances and Armand Hammer Purchase Fund M.69.18

When John Singer Sargent returned to the United States in 1889 to arrange matters connected with a mural commission for the Boston Public Library, he had already earned international prominence as a portrait painter. Sargent spent June of 1890 in Worcester, Massachusetts, executing what proved to be among the most important of numerous portrait commissions from New York and Boston clients. His subjects, the socially prominent Mrs. Edward Livingston Davis and her young son, posed for Sargent in the Davises' stable, partly because it was high enough to accommodate the tall easel, and partly because its shadowy volume gave him a dramatic dark ground that avoided allusion to a specific location. This device enabled Sargent to focus on the characters and relationship of the pair.

Mrs. Davis stands, a convention of formal portraiture, and her grace and composure are conveyed in her upright posture and direct gaze. While she and her son do not look at each other, the warmth of their relationship is evident in their clasped hands and in the casual but tender embrace that shelters the child. Humor, affection, and resolve are revealed in the woman's spirited presence; patience and serenity, in the boy's. As in his other family portraits Sargent avoids sentimentality.

In this double portrait Sargent achieved a technical and formal tour de force as well as a sensitive and complex psychological study. Combining a dark palette with strong lighting, as if the pair were standing just inside the stable door, Sargent gained an overall effect of brightness. Following his early French master, Émile Carolus-Duran, Sargent here exploited the limits of his dark range of colors by taking advantage of tonal shifts in the blues and browns of the dress and background. The broad, loose brushwork acknowledges Sargent's debt to Dutch and Spanish masters, among them Frans Hals and Diego Velásquez, while the firm modeling and dramatic lighting of the woman's head share the realism of John Singleton Copley, whose work Sargent discovered in Boston.

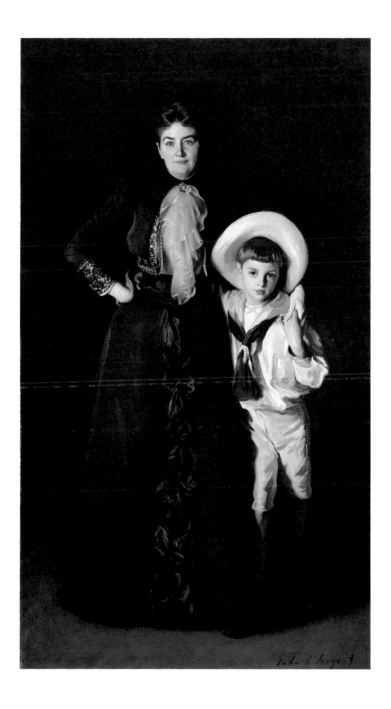

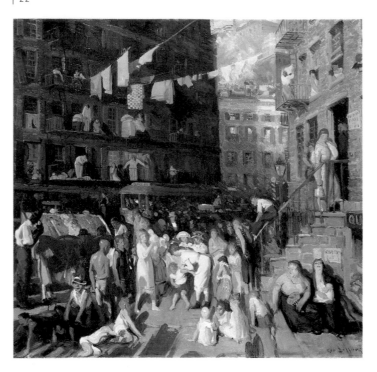

GEORGE WESLEY BELLOWS
United States, 1882–1925
Cliff Dwellers, 1913
Oil on canvas, 40⅛ × 42 in. (101.9 × 106.7 cm)
Los Angeles County Fund 16.4

George Wesley Bellows studied with the influential painter Robert Henri at the New York School of Art starting in 1904. Although not one of The Eight, the group of American artists allied with Henri in a rebellion against academic painting, Bellows was associated with them and shared their preoccupation with vigorous execution and urban subjects.

Talented and widely recognized, Bellows at age twenty-seven became the youngest artist ever designated associate of the National Academy of Design. But he continued to support the avant-garde, and in 1913, the year he gained full academician status, Bellows exhibited in the pivotal Armory Show, which he helped organize.

Because of its urban subject matter *Cliff Dwellers* has been interpreted as a critical social statement. Its meaning was confused by the fact that Bellows made a similar study with the editorializing title, "Why don't they go to the country for a vacation?" In fact Bellows and most artists of his group stopped short of overt polemics in their work. The true subject of his painting is the vitality and pleasures of the urban poor, not their deprivation or oppression. The mother ascending the staircase is reminiscent of works by Honoré Daumier and Jean-Baptiste-Siméon Chardin that depict women as the mainstays of family life. The group of young men, women, and tussling boys sets a tone of innocent joie de vivre. Behind the sunlit foreground, shadowed tenements with their populated balconies form a stagelike backdrop of vignettes suggesting the spontaneity and complexity of the dwellers' lives.

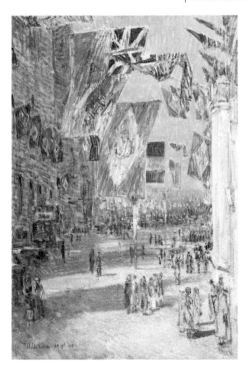

CHILDE HASSAM
United States, 1859–1935
Avenue of the Allies: Brazil, Belgium, 1918
Oil on canvas, 36¼ × 24¼ in. (92.1×61.6 cm)
Mr. and Mrs. William Preston Harrison Collection 29.18.1

Childe Hassam was among the earliest and most significant of the American impressionists. He studied in Paris under Jules Lefebvre from late 1886 to the summer of 1889, became active in artists' organizations throughout the United States, and in 1897 was instrumental in establishing Ten American Painters, a group of American impressionists who seceded from the Society of American Artists because of its conservative policies.

Cityscapes dominate Hassam's work. Early in his career he painted views of Boston; in the late 1880s he painted views of Paris. Watercolors and a small oil completed between 1887 and 1889 foretell his interest in flag paintings, and in 1910 Hassam depicted crowds celebrating Bastille Day in Paris's flag-decorated rue Danou. He began the first of many paintings with flag themes in 1916, in the patriotic atmosphere that marked the entry of the United States into World War I. This work depicts the block of Fifth Avenue between Fifty-fourth and Fifty-fifth streets; each block was devoted to the flag of one nation. The large flag of Brazil commands the scene, flanked by a British ship-of-war flag and that of Belgium.

Hassam's earlier street scenes emphasize figures and crowds, but here the flags are paramount. Tall, sheetlike buildings frame the street. The flags are viewed from below, accentuating their scale. Against the light sky they create a lively two-dimensional pattern of color and design that dominates the crowded street. A sense of spaciousness and movement is conveyed through the light palette and sketchy, even unfinished brushwork.

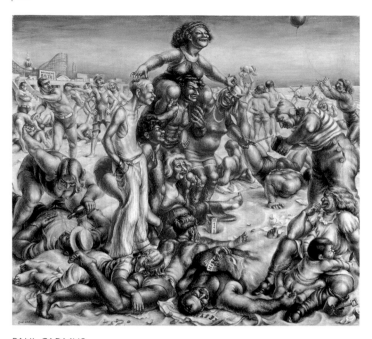

PAUL CADMUS
United States, born 1904
Coney Island, 1934
Oil on canvas, 32⅜ × 36¼ in. (82.2 × 92.1 cm)
Gift of Peter Paanakker 59.72

It is possible to see *Coney Island* as a kind of editorial cartoon or social commentary in the vein of satirical post-Ashcan school artists Reginald Marsh and Ivan Albright, who depicted American grotesqueness in the 1920s and 1930s. But at the time he made this painting, Paul Cadmus remarked: "I like Coney Island because of . . . the crowds of people in all directions, in all positions, without clothing, moving — like the great compositions of Michelangelo and Rubens." Despite its preoccupation with coarse, unsymmetrical, and excessive flesh, this study exhibits humor and affection. Exaggerated in all ways, garishly outlined in shocking pink, these figures speak more of men's follies than of their crimes, reflecting Honoré Daumier's mockery rather than George Grosz's rage. Elements of the inane, the uncouth, and the ridiculous are all present, but not the vicious or perverse.

The painting is carefully composed, according to classical principles of perspective and foreshortening, around the center, pyramidal group. Each figure is drawn from life, anatomically correct. Their twining limbs evoke something of Hieronymous Bosch's frenetic fantasies, while the overall assemblage of men, women, children, dogs, toys, and litter strongly recalls the populous, witty, often allegorical genre scenes of Pieter Breugel the Elder.

Coney Island was roundly denounced by the Coney Island Showmen's League when it was exhibited in 1934 at the Second Whitney Biennial, where it received the same hostile reception that critics and the public accorded Cadmus's other works in this vein.

ANCIENT AND
ISLAMIC ART

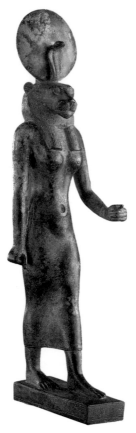

SEKHMET
Egypt, 26th Dynasty (about 664–525 B.C.)
Bronze, h. 13 in. (33 cm)
William Randolph Hearst Collection 50.37.14

Egyptians of ancient times represented their deities by human forms as well as by inanimate objects, but the animal imagery ingrained in their pantheon is among the most intriguing. Lions, crocodiles, snakes, ibis, rams, scarab beetles, and frogs all appear in Egyptian religious imagery.

Before the First Dynasty (about 3000 B.C.) local priesthoods developed their own pantheons; images of their gods are preserved in the form of ritual objects as well as in depictions of sacred emblems and banners. When the Egyptian state was unified, a fairly stable state pantheon, assimilated from many variant local god forms, was codified by priests at the sanctuary of Ra (the sun god) at Heliopolis. Some deities previously represented only by symbols or objects acquired human forms with identifying headdresses. Gods embodying abstract and universal qualities were usually depicted in human form, often swathed like mummies; among these was Ptah, shaper of the universe, gods, and men.

Sekhmet, Ptah's consort, retains a part-human-part-animal form. She wears the royal headdress of sun disk and cobra. The slim, taut body and alert leonine head unite the natural and supernatural forces she represents. Her extended arm originally held a staff. Called "the eye of Ra," Sekhmet used the sun's terrible heat to vanquish the wicked in the underworld. This ambivalence — the sun both giving and destroying life — pervades Egyptian cosmology and is often a source of its varied and imaginative deity forms.

This bronze figure is a temple or burial gift; the donor's name, Penetch, is inscribed on the plinth.

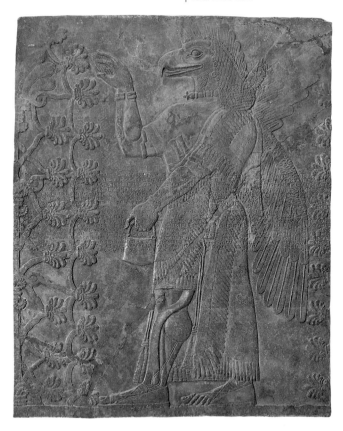

EAGLE-HEADED DEITY
Assyria, Kalah, palace of Ashurnasirpal II (r. 883-858 B.C.)
Alabaster, h. 88 in. (223.5 cm)
Gift of Anna Bing Arnold 66.4.4

Imperial architecture of the great kings of ancient Assyria incorporated
standing slabs of stone carved and often painted with scenes of battle,
ritual, and the hunt. Five panels in the museum's collection once stood
in Ashurnasirpal II's Northwest Palace, a mazelike complex of more
than two hundred reception halls, courtyards, sanctuaries, private quar-
ters, and administrative offices at Kalah, not far from biblical Nineveh.

Although they come from at least two different parts of the palace,
the panels share several themes. Each repeats a cuneiform text asserting
the king's claim to absolute power and fealty to the gods who bestowed it
on him, his geneaology and legitimacy of descent, and his accomplish-
ments and conquests. Two corner panels depict a tree of life with
interlaced trunk and many-petaled flowers, and three depict benevolent
winged mythical creatures.

The eagle-headed being touches traditions and beliefs that go back a
thousand years in Mesopotamia, when similar images of terra-cotta were
buried beneath dwelling floors to assure the safety and prosperity of the
house. The deity appears to be anointing or fertilizing a tree with pollen
from a vessel, perhaps with a fir cone or date-palm spathe. The spirit's
bared and advanced foreleg, an iconographic convention, indicates action,
while a wealth of detail — coiffure, bracelets, tunic patterns — animates
its hieratic posture.

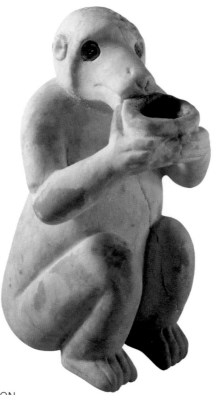

SEATED BABOON

Iran, Elamite, second half of 3rd millennium B.C.
Gypsum, h. 4 in. (10.2 cm)
Purchased with funds provided by the Eleanor Pinkham bequest,
The Ahmanson Foundation, and the Museum Acquisition Fund M.87.39

Composed of a loose federation of city-states bordering Mesopotamia, the Elamite states (today southwestern Iran) became the leading political force in ancient western Asia from the third to mid-first millennia B.C. The Elamites engaged in frequent warfare and cultural interaction with various Mesopotamian peoples, including the Sumerians, Akkadians, Babylonians, and Assyrians. Their cuneiform records reveal most of what is known about them today.

A tradition of portraying animals in human attitudes emerged in Elam during the fourth millennium. Zoomorphic vessels of stone and terracotta depict apes, bear cubs, lions, birds of prey, and pigs. Many served as cosmetic vessels and may have been dedicated as offerings. This baboon image relates to them as well as to a series of small human stone figures presenting offerings, produced in Elam around 3000-2900 B.C.

Although not native to Mesopotamia, monkeys and baboons, considered fabulous beasts, were known at court and given as gifts and tribute. This small, round-eyed sculpture is of a baboon (*Papio cynocephalus*) native to East Africa and Kenya. Fairly gentle, it usually walks on all fours but here takes a human posture, presenting a bowl still containing remains of an offering. Ancient texts disclose that monkey bone and hair were believed to ward off or cure disease; this suggests that monkey figurines were considered to have magical powers and were greatly valued.

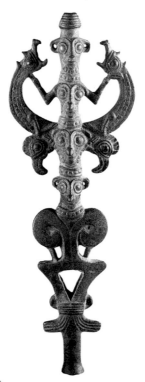

STANDARD FINIAL
Iran, Luristan, Iron Age II-III (about 1000-650 B.C.)
Bronze, h. 8 in. (20.3 cm)
The Nasli M. Heeramaneck Collection,
gift of The Ahmanson Foundation M.76.97.5

The mysterious figures, visages, and animals of this bronze staff orna-
ment are no less enigmatic than their role in the life and ritual of the tribal
and pastoral societies of ancient Iran. Because objects such as this finial,
along with weapons and elaborate horse trappings, were prolific in grave
mounds in the mountainous Luristan region of western Iran, it can be
inferred that they were produced by a society skilled in crafts, wealthy
enough to patronize artisans, sophisticated enough to possess complex
religious observances and imagery, and deeply concerned with the well-
being of the dead in the afterlife. We can know little more, since the
fragile historical record of most major Luristan grave sites was destroyed
during a period of international collecting enthusiasm in the 1920s
and 1930s.

Shadowy traces of Indo-European motifs in some Luristan artifacts
hint of contact sometime in the second millennium B.C., while weapons
and goblets slightly earlier than this finial bear inscriptions attesting to
contact with the kings of Elam and Babylon. By the eighth century B.C.
Assyrian records report connections with Lurs culture through conquest
or trade. All these strands are woven into the imagery of this ornament,
whose lower human form is surmounted by an elaborate headdresslike
structure. The second head, part of this horseshoe-shaped assemblage,
is topped by a torso-length figure on whose chest a third head appears,
its eyes also reading as breasts. The upper figure fends off two elongated
predatory creatures springing from two rooster heads. The identity and
meaning of these images remains tantalizingly obscure.

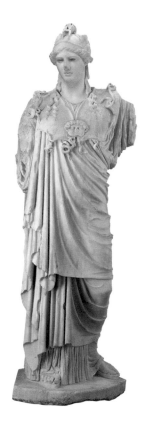

THE HOPE ATHENA

Italy, Ostia, 2nd century A.D. after a
Greek original of the 5th century B.C.
Marble, h. 86 in. (218.4 cm)
William Randolph Hearst Collection 51.18.12

This figure of Athena was excavated in Ostia, the port of Rome, in 1797, along with a figure of Hygeia, goddess of health. Both once stood in large niches in the wall of a ruined Antonine palace. Their size and commanding presence suggest they were viewed in some sort of public context.

The sculptor of this work may have seen numerous older Greek and Roman copies based on a prototype Athena of classical Greece. But examples of original Greek sculpture were no longer extant by the time collectors of the eighteenth and nineteenth centuries began to enthusiastically acquire and restore works from antiquity. Restorers could draw only on descriptions preserved by classical writers, particularly the Greek geographer and traveler Pausanias (fl. A.D. 174).

Pausanias described the famous helmeted and victorious Athena Parthenos, a monumental ivory and gold cult statue by Pheidas. Installed in the *naos* (inner sanctuary) of the Parthenon in 438 B.C. as part of a civic embellishment campaign under the great Athenian statesman Pericles, this figure embodied the identity of her city. In her left hand she held a spear, in her right a Nike, winged personification of victory.

The Englishman Thomas Hope acquired this work in 1804 and had the statue's missing arms and emblems restored, and thus she remained until the 1920s. But today Athena appears in almost the same state in which she was recovered in 1797. Modern restoration philosophy prefers removal of anachronistic and possibly erroneous additions in favor of studying the original, though partial, work. The fact that this Athena survives today in numerous copies and variants indicates how much the image was valued in ancient times.

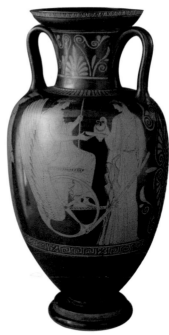

RED-FIGURE NECK-AMPHORA
Attributed to the Hector Painter
Greece, Attica, about 440–430 B.C.
Ceramic, h. 19¼ in. (48.9 cm)
William Randolph Hearst Collection 50.8.23

Between the seventh and second centuries B.C. huge quantities of Greek decorated pottery were shipped all over the ancient world. Corinth claimed this market until overwhelming demand caused careless and mechanical production. Athenian potters, who had mastered sophisticated kiln techniques employing sequences of oxidation and reduction firing, next came to dominate the export trade, first with black-figure and then red-figure vases, executed with enormous skill in a great variety of shapes. Extraordinary numbers survive; their imagery reveals much about the ancient Greeks' life and mythology.

This two-handled amphora, used to store wine or olive oil, is decorated with the trio responsible for the seasons, harvest, and fertility. In the winged chariot sits the demigod Triptolemos, who taught mortals the arts and techniques of agriculture. Behind him stands his foster mother, Demeter, patron goddess of agriculture. Her daughter Persephone pours wine from an oenochoe into Triptolemos's extended phiale, a broad, shallow wine cup.

Triptolemos and Demeter carry stalks of wheat, and Persephone holds the torch that lights her way in the underworld, where she is confined part of each year, causing winter to appear in the mortal world. Upon re-emerging she brings spring with her, an annual cycle of renewal that was a major preoccupation of much of Greek religion and ritual.

Greek painters are often named after their vases and are identified by motif and style; few vases are actually signed. The Hector Painter is named for a vase that depicts a scene from Homer's *Iliad* in which the Trojan prince Hector sets out for war.

BEAKER WITH A THEATRICAL SCENE
Probably Syria or Egypt, late 2nd–3rd century
Free-blown, painted, and gilded glass; h. 5¾ in. (14.6 cm)
Gift of Hans Cohn M.87.113

This Roman glass beaker, reportedly found in Egypt, is a rare artifact and represents the kind of sophisticated luxury glassware produced for the Roman elite.

The beaker's chief decoration is a painted scene composed of two men flanking a couple; the men wear short chitons and the woman a long tunic. A pair of unsupported doors reveals that this is a stage set and the figures are actors. Partial inscriptions in Greek appear above the heads of each character, giving the gist of their dialogue, which places the scene in a fashionable bordello.

Just to the right of one door, a disgruntled client named Oinopotes (Winebibber), a stock-character fool and butt of ridicule, prepares to depart while lamenting the high price of courtesans' favors and perhaps their lack of generosity. In the center, a tall, well-dressed man identified as Pornoboskos, keeper of the establishment, offers him another, more economical companion (illustrated). But she declines, pleading a prior engagement. The last figure, a slave or attendant, offers a general commentary on the failed transaction.

Although this tableau lacks a specific dramatic reference, it is typical of the many anonymous Roman farces based on Greek comedies of the Hellenistic period, particularly the stereotypical plots and characters of topical parodies and satires known as New Comedy. Illustrated papyri of New Comedy plays may have provided glassmakers with sources for such popular scenes.

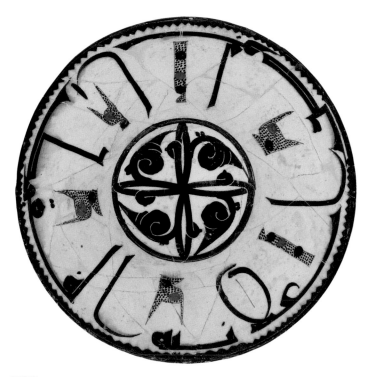

BOWL
Northeastern Iran or western Turkestan, 9th–10th century
Underglaze painted ceramic, diam. 8⅞ in. (22.5 cm)
The Nasli M. Heeramaneck Collection, gift of Joan Palevsky M.73.5.199

The development of indigenous Islamic ceramics in southern Mesopo-
tamia was spurred during the ninth and tenth centuries by a dramatic
shift in the way ceramic wares were perceived. The artistic potential of
the coarse-bodied and commonplace native ware was quickly reassessed
upon the arrival, apparently in Baghdad and presumably at court, of fine
imported Chinese Tang porcelains and polychrome stoneware. Native
potters quickly assimilated the shapes and decorative effects of these
Chinese wares into a uniquely Islamic ware that in subsequent centuries
attained great originality and luxury status and was widely exported.

The provincial regions of northeastern Iran and western Turkestan
were the two main ceramic centers during the ninth and tenth centuries.
Most evocative of the visual impact of early Islam was the development
of an elegant ceramic ware featuring spare, restrained, and sophisticated
abstract decoration, as on this bowl. Such wares characteristically show
proverbs and blessings in Kufic script with letter forms having long,
graceful descenders, as well as zigzag edging, calligraphic bird forms,
and center medallions, here a palmette with scrolled leaf forms. Human
figures never appear.

These potters also developed painting with slip, a liquified clay. The
white slip ground of this plate is an early effort to achieve the white field
so valued in imported Chinese porcelains.

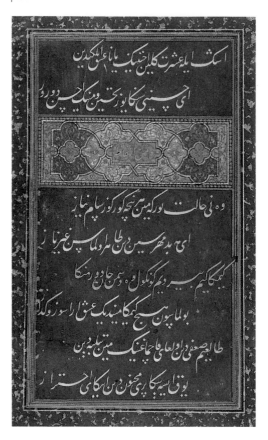

PAGE FROM THE *DIWAN* OF SULTAN HUSAIN MIRZA

Iran, late 15th–early 16th century
Opaque watercolor, decoupage, and gold
on paper; 8⅞ × 5¾ in. (22.5 × 14.6 cm)
The Nasli M. Heeramaneck Collection, gift of Joan Palevsky M.73.5.599

A flourishing court patronage of the arts marked the long reign (1467–1506) of Sultan Husain Mirza ibn Baiqara, great-great-grandson of Tamerlane (Timur). At his court in Herat calligraphers, painters, musicians, philosophers, and theologians received generous support. The rule of this last Timurid sultan established a watershed of cultural attainment in Persian arts and letters.

The power of the word is esteemed in Islamic culture because Muhammad, the prophet of Islam, received the entire Qur'an (Muslim holy scripture) verbally from God through the angel Gabriel. As a result, books and bookmaking were revered, and skill in calligraphy was valued above skill in depiction. This high regard is borne out by this page from Husain's *diwan*, a term with numerous meanings but here referring to the collected works of Husain's own poetry. The diwan's production and embellishment by court artists might have continued over many years.

These lines from a mystical love poem were composed in Arabic letters but written in Chaghatai, an eastern Turkic language of Central Asia. This use of Arabic characters emphasized the Timurid goal of establishing Chaghatai as a literary language. The white letter forms were not inked but were cut from white paper. The technique of decoupage, often used in Persian bookbindings, was applied here with great delicacy and precision.

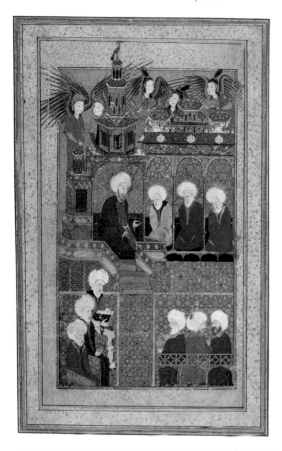

THE PROPHET MUHAMMAD WITH HIS COMPANIONS
Turkey, about 1558
Ink, opaque watercolor, and gold on paper; 8⅜ × 5¼ in. (21.9 × 13.3 cm)
The Nasli M. Heeramaneck Collection, gift of Joan Palevsky M.73.5.446

Public Islamic documents and buildings are never embellished with por-
trayals of living things, but private books, usually shared only with family
and close associates, contain a rich legacy of figurative depiction that
draws on Persian, Chinese, and Byzantine pictorial traditions.

This painting is most likely the only surviving page of the second of
five volumes of the *Sahname-i Al-i Osman*, a history of the Ottoman
dynasty. The last volume is devoted to the patron of the work, Suleyman
the Magnificent, whose long reign (1520–66) formed the apogee of the
Ottoman Empire. Now an album leaf, the image may originally have
been accompanied by text. Inscriptions above the arches name Suleyman,
alluding both to him and to King Solomon of the Old Testament.

The composition in three registers reflects Ottoman preoccupation
with structure, frontality, and patterning. Six men below are observers
with no discernible identities. In the middle register Muhammad sits in
the minbar (pulpit) addressing an audience of three. Their flamelike
aureoles imply that they are companions of the Prophet. Above, five
angels, winged in the Judeo-Christian-Islamic tradition, perch among
domes of the mosque. Their pinion feathers escape the drawn frame,
evidence of the Ottoman artist's inclination to experiment with page
composition even when depicting iconic subject matter.

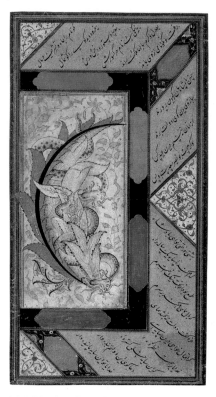

DRAGONS ENTWINED ON A SPRAY OF FOLIAGE

Turkey, about 1575
Ink, color washes, and gold on paper; 7⅛ × 3¾ in. (18.1 × 9.5 cm)
The Edwin Binney, 3rd Collection of Turkish Art M.85.237.18

Between 1555 and 1600 Ottoman court painting developed in two ways. A pictorial style deriving from book illustration traditions of Iran was used to embellish historical and literary texts with linear, realistic depictions and ornate, two-dimensional geometrical patterning. By contrast the *saz* style, named for the reed pen that produced its characteristic line, had curving leaves, flowers, vines, and creatures of imagination and legend. It too had antecedents in the Persian tradition but drew from decorative idioms, which during the fifteenth century emphasized Chinese motifs that had earlier entered Persian artistic vocabulary through contact and trade, hence the ubiquitous dragon in saz-style drawings.

Executed in complex and minute detail, a pair of dragons, barely distinguishable, writhes among fleshy foliage in this rare album drawing. The strong arc of the dark palmette spine, a typical saz-style element, anchors the composition.

The album was a private, often idiosyncratic book form composed of poetry, calligraphy, painting, and drawing compiled by an owner or commissioned by a patron. Neither the poetic text, which might have been added later, nor the striking diagonal composition of this page has any direct relation to the mounted drawing.

Saz-style drawing reached well beyond the court. Even after it ceased to be innovative, around 1600, it continued to appear in architectural decoration, weaving, and export goods, lingering to influence European decoration to the end of the eighteenth century.

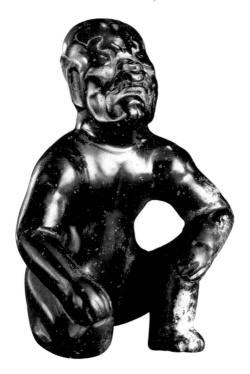

CROUCHING FIGURE OF MAN-JAGUAR
Mexico, Olmec, Tabasco(?), Middle Preclassic period,
about 900-300 B.C.
Serpentine with traces of cinnabar, h. 4¼ in. (10.8 cm)
Gift of Constance McCormick Fearing M.86.311.6

The Olmec civilization of Mexico's coastal lowlands (Veracruz and
Tabasco states) left evidence of an agricultural society, a time-recording
system similar to that later used by the Mayans, monumental stone
sculptures and architectural ruins, and exquisitely carved jades found at
their great ceremonial complexes such as San Lorenzo, Tres Zapotes,
and La Venta. For all this evidence of technological ability, iconographic
complexity, and distinctive style, however, the enigmatic Olmecs left no
coherent record revealing the totality of their cultural life, their begin-
nings or their end.

The jaguar and its human form, the were-jaguar, pervade Olmec art.
This man-jaguar's massive torso and compact limbs form a monumen-
tally conceived sculpture, despite its small size. The green serpentine
body once held cinnabar in various carved depressions; its eyes were
inlaid with small pyrites. This rare transformational figure is a jaguar,
not a masked human. Its skin and hair are peeled back to reveal a
spiritual feline.

Today peoples of some remote South American tribes use the same
word for "jaguar" and "shaman," indicating an intimate connection
between the secretive predator and shamanic identity. The totemic jaguar
may signify both health and sickness, protection and destruction, and
the actual appearance of a jaguar in the jungle is believed to influence
the well-being of individual and community. This profound and complex
mystical fellowship between man and cat may be a living link with the
vanished Olmecs.

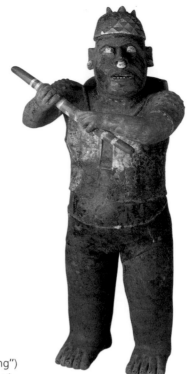

STANDING WARRIOR (The "King")
Mexico, Jalisco, El Arenal Brown style,
Late Preclassic–Early Classic period, about 100 B.C.–A.D. 300
Ceramic with red slip, yellow, white, and black paint;
37×15 in. (94×38.1 cm)
The Proctor Stafford Collection, purchased with funds provided
by Mr. and Mrs. Allan C. Balch M.86.296.86

The study of Mesoamerican cultures of western Mexico (Nayarit-Colima-Jalisco) is beset with perplexities. While artifacts are abundant, complex, and well preserved, there remains no imposing temple or town ruins, no written language, no coherent historical matrix to give them context and meaning in the present day.

Between 200 B.C. and A.D. 500 these societies built a unique mortuary complex, the subterranean shaft-and-chamber tomb. With their dead they buried stone tools, bone and shell ornaments, mats, fabrics, musical instruments, and thousands of ceramic vessels and effigy sculptures: animals, performers, musicians, warriors, acrobats, hunchbacks, groups of palanquin bearers, entire teams of ball players.

From this variety we can glimpse a primarily agricultural society, perhaps settled around a few ceremonial centers, in which rank, ritual, and especially shamanic practice had a part. An ambiguous distinction between present life and the afterlife may explain these well-stocked tombs.

This figure from a Jalisco burial is the largest known effigy from western Mexico. Its elongated head, axe-shaped nose, upper arm "buttons," and jutting buttocks are characteristic of the El Arenal Brown style, as are the red slip coating, white eyes, and details painted in rust-colored slip. Made in one piece, it is a tour de force of firing. The headgear may be a helmet or have ritual significance; the staff may be an official emblem, a weapon, or a game piece. Although its identity remains beyond reach, its imposing size and presence suggest a warrior, official, or king.

COSTUMES AND TEXTILES

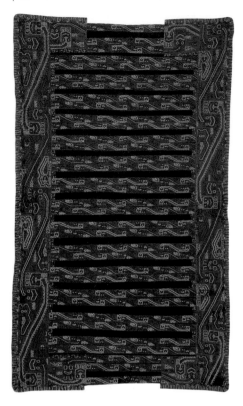

BURIAL MANTLE

Peru, Paracas, 300 B.C.-A.D. 300
Polychrome embroidery on alpaca wool and cotton ground,
98⅛ × 57¼ in. (249.2 × 145.4 cm)
Los Angeles County Fund 67.4

Like the ancient Egyptians and the Chinese, Pre-Columbian peoples interred their dead with furnishings for the afterlife. In coastal Peru's dry climate ancient textiles have survived in remarkable numbers, emerging from their long darkness with astonishing freshness of color. Some date to two thousand years before Spanish contact.

Mantles, turbans, ponchos, shirts, and belts were wrapped in as many as four layers around the body to form a conical mummy bundle; a single burial might include as many as twenty pieces of clothing. This mantle, a precious early example of the weaver's craft, was found in the necropolis at Paracas on the south coast of Peru. Its vivid coloration is typical, as is its composition of native alpaca wool woven on cotton warps.

Weaving in Peru goes back to about 2000 B.C. and displays considerable sophistication and technical expertise. This mantle is composed of two longitudinal pieces and the borders, which have been sewn together and then embroidered with stitches, such as stem and buttonhole, still used today in hand sewing.

The design includes motifs typical of Paracas textiles: reversed interlocking figures, often with frontal heads, and composite animals. Here the double-headed serpent of the borders has a cat's head; another feline creature provides a secondary motif. These catlike creatures are probably jaguars, shamanic animals of ancient mythological lineage and a frequently used motif in Pre-Columbian textiles.

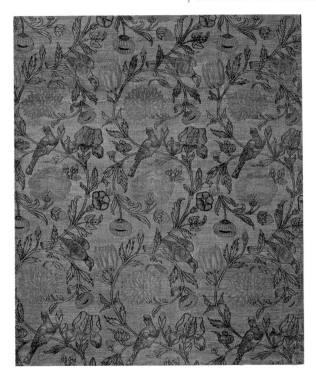

FRAGMENT OF A DRESS OR FURNISHING FABRIC (detail)
Iran, 17th century
Polychrome silk and silver on a white silk core, brocaded
compound weave; 59½ × 20½ in. (151.1 × 52.1 cm)
The Nasli M. Heeramaneck Collection, gift of Joan Palevsky
M.73.5.783

Great garden builders as well as warriors, certain Persian rulers were known to have had outstanding plant collections, particularly of the exotic tulip. They often commissioned arts that featured images of the flowers they grew and prized. As a result Persian manuscripts and textiles reveal a catalogue of Near Eastern plants; the lost gardens of Safavid Iran have been reconstructed in part from these works.

Carnations or pinks, the large upright standards of the iris, and the cupped petals of tulips are identifiable in this textile. This particular design is typical of Persian art of the second half of the seventeenth century. Scholars have suggested that it was influenced by the work of Shafi-i-Abbasi, a court painter who visited Mughal India and was inspired there by court interest in botanical illustration. He produced a number of naturalistic drawings for textiles, which seem to have been widely influential in Iran.

Although the flower forms are natural, there is an element of artifice and restraint in the repeating vine pattern, which sprouts such disparate blooms, and the birds, which perch at such regular intervals. This balance between abstraction and naturalism was a permissible way to deal with Muslim theological opposition to the depiction of living forms.

The weaving of this brocaded compound twill is exceptional in its fineness and detail. Prized in the Near East and coveted in the West, these fabrics found their way into European royal collections and churches in the seventeenth and eighteenth centuries.

THE ARDABIL CARPET
Iran, 1540 (A.H. 946)
Wool and silk, 23½ × 13 ft. (716.3 × 396.2 cm)
Gift of J. Paul Getty 53.50.2

Among the world's most famous artifacts, the Ardabil carpet and its mate in the Victoria and Albert Museum, London, are products of the great flowering of the arts, particularly textile and book arts, under the Safavid rulers of Iran. The site of Ardabil in northwest Iran was sacred to these Shi'ite rulers; tradition holds that both carpets were presented to the shrine there as royal gifts. Although its inventories record nothing like them, other magnificent gifts to this shrine — an entire library of sacred and secular Islamic texts, a treasure of Ming dynasty porcelain, as well as lamps, silk brocades, and candlesticks — confirm the esteem in which these princes held it.

Both versions of the carpet are signed and dated early in the reign of Shah Tahmāsp I, a renowned patron of the arts, and were probably made in Tabriz, a site of royal textile manufacturing, from a high-grade wool identified as coming from royal herds kept there. Also at Tabriz were highly skilled workshops capable of mustering crews able to concentrate on masterworks for extended periods of time. This carpet contains 35,000,000 knots and probably took eight to ten craftsmen more than three years to complete.

The carpet's subtle design, dominated by a large central medallion, is typical of Tabriz work. The overall scheme seems largely abstract, but individual motifs have figural sources. Sixteen ogival shapes surround the central sunburst medallion, and a pair of mosque lamps in the vertical axis flank the design. The undulating border forms derive from Chinese cloud-band motifs. Over the shimmering indigo surface is a meticulously balanced, if botanically improbable, meander of blossom-laden vines. The blossoms are a typical Sasanian lotus palmette crossed with a Chinese peony, some in full bloom and others barely emerging from buds. At the center of the great medallion is a rondel shaped like a geometrical pool of the kind that still exists in the Islamic gardens of the Alhambra in Spain. Such pools were essential to both the design and concept of Persian gardens, an art form that evoked the pleasures of paradise for the Muslim believer.

Identical inscriptions are woven into each of the carpets: Except for thy haven, there is no refuge for me in this world: / Other than here, there is no place for my head. / Work of a servant of the court, Maqsud of Kashan, 946. This evocation of a heavenly refuge is particularly appropriate for a work of art that recalls the abundance and fertility of the garden, the most powerful symbol of physical and spiritual peace in the Muslim world.

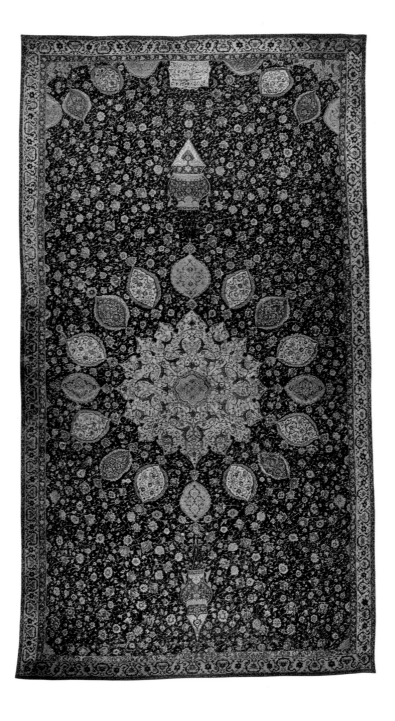

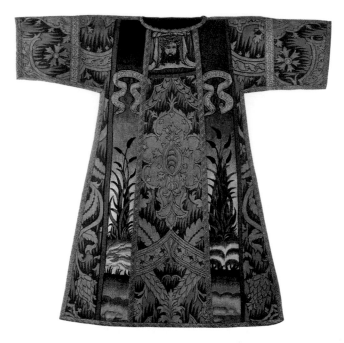

DALMATIC

Holland, 1570
Polychrome wool and silk, interlocking tapestry weave;
cb.* 43¼ × 45½ in. (109.8 × 115.6 cm)
Gift of Mrs. Ellie Stern, Bullocks Wilshire, and the Costume Council
M.79.117

This dalmatic is part of a rare complete set of ecclesiastical vestments surviving the troubled period of the Protestant Reformation in sixteenth-century Holland. Its preservation and that of its companion pieces — today in the Metropolitan Museum of Art — are of special interest because the robes share a linked symbolism and can be dated to 1570 from an inscription on one of the Metropolitan garments.

We are bent, not broken by the waves, translates the motto woven on the banderoles of the design, a particularly appropriate sentiment for Dutch Catholics. From the 1560s they had endured Protestant hostility against the church and its clergy, a situation prevailing in Utrecht until 1580, when Roman Catholic public worship was finally suppressed.

This robe bears the coats of arms of the Van Der Geer and Van Culenborch families of Utrecht, probably confirming that the set was commissioned for use in a private chapel, a timely decision in light of events. The biblical imagery is also fitting; the bullrushes rising above the waves allude both to the inscription and to Moses, who led the Israelites out of their bondage in Egypt.

This message of salvation has been interpreted with technical virtuosity. The dalmatic is done in a flat tapestry weave, but its design imitates piled Italian velvets. The fabric panels also include embroidery accentuating details of the design, suggesting that this unusual combination of techniques was an effort to achieve a richness of surface normally associated with more costly imported textiles.

*center back

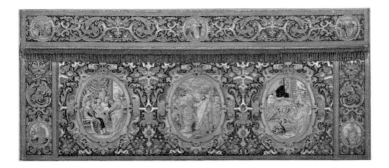

ALTAR FRONTAL
Italy or Spain, about 1600
Silk with metallic gold thread and semiprecious stones,
45 × 110 in. (114.3 × 279.4 cm)
Costume Council Fund M.66.71

This elaborate altar frontal was made for the church of Valletta dedi-
cated to John the Baptist on the island of Malta. The frontal bears three
large medallions with scenes from the saint's life. At right, John is born,
a scene combining, with typical Renaissance sensibility, homely detail
with spiritual significance: John's mother, St. Elizabeth, is attended by
women who offer her sweetmeats and by angels. At center, Christ is bap-
tized by John in the Jordan River. At left, John reproves King Herod,
whose daughter, Salome, will later take revenge by demanding the saint's
head, one of the Bible's most famous episodes.

These primary scenes, framed by gemstones set in the borders, are
surrounded by five smaller medallions. Four have iconic themes, but the
lower right depicts a Maltese bishop blessing the donors of this altar
frontal, emphasizing the fact that it was made for a particular chapel. It
is not certain that the altar frontal was actually made in Malta; it may
have been commissioned in Italy or even Spain in order to obtain the
skills of a professional embroidery workshop equal to the elaborate task.

The frontal is embroidered in gold and silk threads on a red silk velvet
ground. Its scrolls and floral motifs recall the larger vocabulary of Renais-
sance architectural ornament, but smaller details of the background
design are symbolically appropriate to the altar and the celebration of
the mass. For example, the bunches of grapes near the lower border
would suggest to a Renaissance viewer not only the sensuous beauty of
God's bounty but also the wine of the Eucharist and Christ's sacrifice
on the cross.

PRIEST'S ROBE (*kesa*) (detail)
Japan, Edo period, late 17th–early 18th century
Silk and metallic lamella (foil adhered to paper),
83 ¾ × 43 ½ in. (212.7 × 110.5 cm)
Gift of Miss Bella Mabury M.39.2.56

The Buddhist priest's robe, the *kesa*, is usually made up of seven to twenty-five narrow panels (*jo*) composed of patchwork squares and assembled into a large, flat rectangle, which, somewhat like a toga, drapes under the left arm and fastens by two corners on the right shoulder. According to legend, its original shape and composition derive from the fine gold kesa that Buddha's mother made for him. Upon Buddha's death a devout disciple carried the kesa to a mountain and there immured himself to await the coming of the future Buddha Maitreya and the end of the world.

The kesa became the prescribed garment for priests. Obeying vows of poverty, they made these robes from donated pieces of old cloth and rags. Eventually the cloaks acquired the status of investiture and were handed down from master to disciple as symbols of priestly descent and authority. As Buddhist ceremonial observance became more complex and hieratic, the patchwork kesa, composed of finer and finer fragments, grew more luxurious.

This seven-jo kesa minimizes the patchwork effect because it was apparently cut from one garment, a Noh robe, and thus retains a strong visual unity. It is patterned with chrysanthemums brocaded on a silk ground; the long floats of silk give the petals their shimmering appearance. Some of the blossoms are outlined in gold. The Four Directional Guardians of Buddhist cosmology are symbolized by the traditional small squares (*shitennō*) appearing in the kesa's four corners.

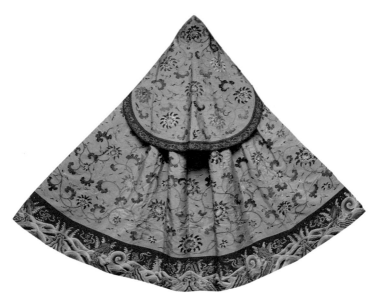

EMPEROR'S HUNTING CAPE

China, 18th century
Polychrome silk, slit tapestry weave (*kesi*);
cape: cb. 59¾ in. (151.8 cm), hood: cb. 34¾ in. (88.3 cm)
Gift of Miss Bella Mabury M.39.2.10a-b

Elements of the allegorical vocabulary of Chinese ceremonial garb appear in this imperial hunting cloak, which is ornamented with some of the many traditional sacred Buddhist symbols that pervade Chinese art.

The body of the cloak is a silk tapestry fabric woven in the *kesi* technique. Over its ground of yellow, a color the Manchu rulers reserved for their sole use, twines a graceful naturalistic network of many-colored lotuses, stems, and leaves. The religious and allegorical allusions of the design begin in the high collarband, where an angular interlace pattern signifies the endless knot, a symbol for Buddha, and the circular rebus incorporates characters for happiness and long life.

Two red front panels depict paired symbols (top to bottom): the wheel of the law, indicating life's endless cycle, and the conch shell, whose sound summons all to worship; the umbrella of state, for incorruptibility, and the canopy of the monarch, who shelters all living things; the sacred vase, containing the water of life, and the tree peony, for summer and prosperity; the endless knot and the paired fish, a rebus for abundance. All are linked by scrolling cloud banderoles. The wide hem border contains still more Buddhist references: waves for the cosmos, coral branches signifying riches, a mountain at the center back for the earth, flanked by castanets symbolizing good fortune.

The cape not only depicts emblems of virtue but also partakes of their power. In donning such a robe, the emperor or prince became invested with power in a complex interaction of magic, ritual, authority, and responsibility.

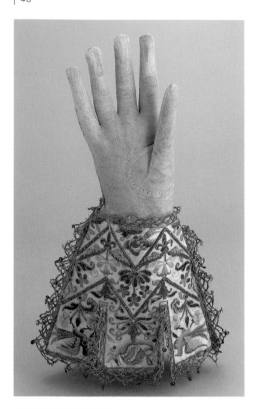

MAN'S GAUNTLETS

England, 1610-20
Leather with gold and silk thread embroidery,
and gilt lace on silk satin; l. 14 in. (35.6 cm)
Gift of Mrs. Margaret Isabel Fairfax McKnight 49.45.1a-b

Decorated ceremonial gloves were widely understood symbols of nobility
and prestige in Jacobean England (1603-25). The right to wear them, a
prerogative of the leisured classes, was eventually protected by sumptuary
laws. James I received gifts of gloves from both Oxford and Cambridge
authorities when he visited those institutions in the early 1600s. Gloves
also served as pledges, challenges to combat, and other signs of status,
such as the right to own a hawk.

These splendid gloves originally belonged to Thomas, first Lord Fairfax
(1560-1640). Their design and construction disclose their use as courtly
attire. The buff leather of the glove hand, a particularly soft goatskin
called castor, is plain, but the elaborately decorated cream satin cuffs, or
gauntlets, render them impractical for any but cermonial use. The tabbed
cuffs are decorated with colorful patterns of flowers, scrolls, and birds
in gold and silk thread embroidery, and gilt lace edging.

Fundamental changes in political and court life hastened the disap-
pearance of such elaborate accessories. Fashions at Charles I's court
(1625-49) were much less extravagant than those of Jacobean times,
and decorated gloves began to seem dated. The Civil War and Common-
wealth years (1642-60), when apparel symbolizing royal favor became
dangerous to display, enforced a Puritan-style simplicity in manners and
fashion. Even after the Restoration in 1660, English courtly apparel
never again attained levels of Jacobean excess.

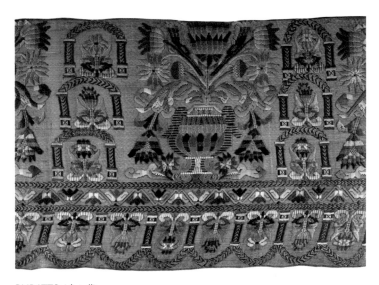

BURATTO (detail)
Italy, Venice, about 1620–30
Polychrome silk, 24 × 215 in. (61 × 546.1 cm)
Costume Council Fund M.86.5.2

In the fifteenth and sixteenth centuries the republic of Venice was the hub of Europe's trade with the East and a dominant power in the Mediterranean. The collaboration of bankers, merchants, and fine craftsmen had made the city the center for a number of luxury trades, among them the manufacture of silk and fine lace. Lace making in Venice maintained its high quality into the seventeenth century, even after the industry, challenged by competition in France and Spain, had declined in the rest of Italy. In Venice it was sustained by wealthy patrons and the strength of the lace-makers' guilds.

In *buratto* work, a combination of needlepoint and a netting technique called *lacis*, a needle, shuttle, and mesh gauge with darned decoration are used. A form of counted canvas embroidery, it is finer, looser, and more flexible than needlepoint. Done on an open-weave backing of stiffened gauze, buratto was used as border trim on clothing and various draperies. Stitched onto velvet, the gauze backing would sink into the pile and disappear from view, leaving the impression that the embroidered pattern was floating on the surface of the fabric.

Bright colors and a vase-and-niche motif reveal a strong Turkish influence in the ten repeats of pattern in this length of buratto. It is still stitched to its original backing of blue paper, which protected the gauze from distortion when handled or rolled.

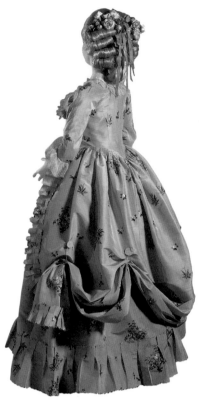

DRESS

England, about 1770-80
Silk taffeta brocaded with polychrome silk;
dress: cb. 63 in. (160 cm), petticoat: cb. 37⅞ in. (101.3 cm)
Costume Council Fund M.57.24.8a-b

Wealthy and fashionable ladies from the 1740s to just before the French Revolution wore as their daily attire either the loosely pleated French gown or "sack," the tightly fitted English gown, or the *robe à la polonaise* with its hitched-up overskirt.

The pale pink color of this dress and its petticoat is typical of the late eighteenth century. The gown features a skirt shorter than its petticoat; buttons and braid hold the overskirt in draped swags at the back. This abundant display of two layers of fabric attested the wearer's wealth; at the same time her dressmaker's skill would have been judged at least in part by her ability to cut the narrow lengths of fabric without waste.

Making such a dress required enormous patience and ability. Each hand-sewn seam has about eight stitches to the inch, and the pinked edges of the ruching were probably done by a specialist using shears designed for the purpose. But despite this labor-intensive procedure, the chief expense by far would have been the very costly fabrics.

A mad vogue for high-piled hairstyles trimmed with ribbons and flowers reached its peak in the 1780s, contemporary with this gown. The combination of a bulky coiffure and a stilted gait resulting from the reintroduction of high heels in the 1770s produced a body shape and stance that designers exaggerated in the robe à la polonaise. Its heavy flounces balanced the elaborate hairstyle, achieving a total effect of a fashionable, if costly, immobility.

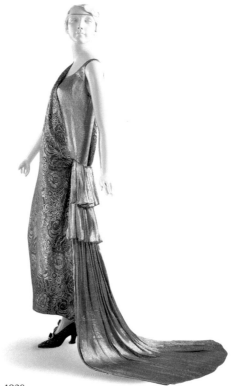

PAUL POIRET
France, 1879-1944
Evening Gown, about 1920
Cinnamon and silver silk brocade, silver lamé; cb. 78 in. (198.1 cm)
Gift of Mrs. Helen Crocker Russell 54.129.2

This brocade and silver lamé evening gown with train was designed by the French couturier Paul Poiret. A relative suppleness of fabric and silhouette distinguish the gown's self-consciously modern design, a modernism particularly associated with Poiret's fashions.

As a young man Poiret was encouraged by leading French designers to experiment with fashion ideas. In 1903 he opened his own couture house and there proceeded to revolutionize women's fashions in ways still felt today. Poiret simply abandoned the unnaturally curved late Victorian female silhouette that was the product of heavily boned and confining corsets. Turning to new, less restrictive undergarments such as the girdle, he designed for a body line less ample of bosom, more boyish, and to modern eyes far more natural.

This evening gown illustrates ways in which Poiret designed for this "new" female form. Luxurious fabric drapes the body in simple folds. The elaborate tucks and darts of the old styles have been replaced by seemingly artless devices, such as the brocade folds that catch at the hips, shaping the flow of bodice and skirt. Poiret's elegant line also displays the handsome fabric; instead of pieced construction, the dress is made of a single length of brocade.

The Eastern flavor of the gown is no accident. Poiret, who traveled in Russia, was a friend of Sergei Diaghilev and was influenced by Leon Bakst's costumes for the Ballets Russes. Poiret's interest in theater and fabric design as well as fashion accords with the then-current art nouveau interest in fusing the fine and decorative arts.

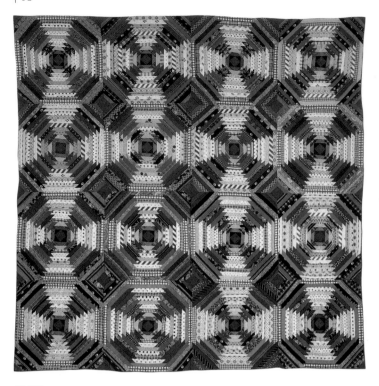

QUILT

United States, Pennsylvania, about 1870-80
Log Cabin pattern, Pineapple variation
Wool and cotton, 88×88 in. (223.5×223.5 cm)
Gift of the Betty Horton Collection M.86.134.18

A part of American culture from the early years of settlement and western expansion, quilting was first a utilitarian act. As a cooperative task, it gave women in small communities a respite from their frequently solitary labors. Their quilts constitute a valued legacy to the present, and in recent years the American quilt has been sought by enthusiasts and museums that recognize the aesthetic merits of its complex geometric patterns and arresting colors.

This variant of the Log Cabin pattern quilt, with its strips set diagonally across the corners of each center square, ends angled and lapped, sets up a lively visual counterpoint. The traditional alternation of light and dark segments in each component square creates spiny pineapple shapes. They advance and retreat, sometimes setting up a visual illusion of wildly spinning, spiky wheels. The center squares of Log Cabin blocks are traditionally red, although other colors are not unusual. Here they are a mosaic of red, blue, and black triangles.

The Log Cabin square is an extremely versatile quilt-building unit with a pleasing architectural strength. The names of its variant patterns reveal metaphors of their origins: Court House Steps, Barn Raising, Running Furrow, Light and Dark. Like the log cabin itself, the quilt is an enduring building block of American life.

DECORATIVE ARTS

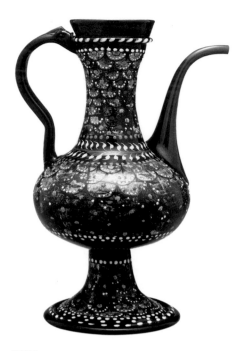

EWER

Italy, Venice, Murano, about 1500
Free-blown, enameled, and gilded blue glass; h. 10 in. (25.4 cm)
Purchased with funds provided by the William Randolph Hearst
Collection, the Decorative Arts Council Acquisition Fund, and
other donors 84.2.1

Although surviving Venetian glass dates only from the Renaissance, early
archaeological and documentary evidence shows that glass was produced
in Venice as early as the seventh century on the island of Torcello and in
the city proper by the tenth century. In 1291, because of fire hazard, the
glassworks of Venice were relocated to the island of Murano, where they
remain today.

The fall of Christian Syria (about 1400) weakened the Islamic world's
domination of the glass market and lent impetus to the Venetian industry.
It is likely that refugee Syrian glassmakers settled in the city at that time,
bringing with them techniques of enamel decoration and gilding inher-
ited from the earlier glassmaking tradition of the Eastern Roman Empire.
Venetian glassmakers came to rely heavily on Islamic vessel forms and
decoration; by 1500 Venice had become the prime source of common and
luxury glass for both Europe and the East.

The strong ties Venice established with the East are evident in this
sumptuous gilded and enamel-decorated ewer. Its shape imitates Eastern
metal prototypes first imported for use in the liturgy. It is one of a group
of ten glass vessels of identical shape but differing decoration. Assembled
from four pieces (body, spout, handle, foot), the ewer is characteristically
Venetian in concept and execution, but Islamic influences appear in the
form of the body and in the band of white flame-pattern enamel on the
neck. The shell gilding with red, green, and yellow enamel dots is typical
of Venetian luxury glass of this period and was meant to imitate gem-
encrusted vessels of gold or silver.

PIERRE COURTEYS
France, Limoges, about 1520-before 1591
Oval Plaque, about 1560
Polychromed enamel with gold on copper,
12¼ × 8⅞ in. (31.1 × 22.5 cm)
William Randolph Hearst Collection 49.26.12

This enameled plaque by Pierre Courteys depicts the introduction to the tale of the love of the mortal Psyche for the god Cupid as told by the Roman satirist Apuleius. The protagonist, Lucius, is a Greek adventurer magically transformed into a jackass. Here he pricks up his ears to listen as an old woman tells Psyche's story to a bride kidnapped on her wedding day and awaiting ransom.

Courteys, a member of a family of skilled enamel painters from Limoges, was noted for his elegant figures and vigorous painting style. He rarely executed original compositions but, like most Limoges enamel painters, obtained ideas from other sources. He made a series of plaques depicting the story of Psyche.

Enamel painting, related to stained-glass painting, was developed in the early fifteenth century, probably in the Netherlands. The brilliant pigments were made from powdered metallic oxides suspended in liquid, applied like paint, then fired. The demanding techniques and meticulous skills of copper enameling were brought to their highest level by the artisans of Limoges, a medieval center of enamel work.

The earliest Limoges plaques (around 1470) were religious images commemorating pilgrimages, shrines, or saints' lives and were used for private worship. By the mid-1500s a more worldly and sophisticated clientele demanded secular subjects and luxury items; enameled plates, plaques, candlesticks, saltcellars, jewel boxes, and mirror backs were produced for the wealthy of Europe. Large plaques like this one were used as architectural ornaments and set into wainscoting and door panels.

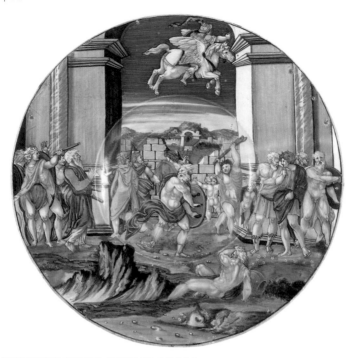

FRANCESCO XANTO AVELLI DA ROVIGO
Italy, Urbino, active 1528–45
Majolica Dish, 1531
Tin-glazed earthenware, diam. 17¾ in. (45.1 cm)
William Randolph Hearst Collection 49.26.3

Tin-glazed pottery was produced in the ancient Middle East by the Babylonians, and the technique — applying a tin glaze painted with metallic oxides to bisque-fired ceramic — has been in use continuously since that time. Hispano-Moresque potters employed it extensively in the fourteenth century, and it became popular, then famous, in Italy. Known there as majolica, the technique developed into a sophisticated art form during the fifteenth century.

Majolica centers were established in Florence, Faenza, and in Urbino, where by 1525 the most notable Italian majolica was produced. Urbino artists improved the glaze palette in range and brightness and also began to use the entire surface of the plate as a pictorial ground, much as if it were a canvas. Vessel forms and styles of depiction gained in scale and complexity; pieces of this sort were commissioned by patrons as gifts or for personal display.

This plate is painted in the *istoriato* (narrative) style, also developed in Urbino. It shows a scene from Ludovico Ariosto's *Orlando Furioso*, an epic glorifying the Estes, an Italian noble family. Here the hero Ruggiero appears on a winged beast between architectural columns, a classically composed group of figures beneath him and a walled city and landscape in the background. The plate is dated *M.D.XXXI* and signed by the artist: *Fra.[ncesco] Xanto Avelli da Rovigo, Urbino*. It also has a curious inscription on the back, to the effect that Ruggiero was an ancestor of the Este family, "which is and always was guilty of every filthy vice." Perhaps the patron who commissioned this plate was obliquely settling an old score.

WII LIAM TAYLOR (attrib.)
England, 17th century
Slipware Charger, about 1685
Lead-glazed earthenware with slip decoration, diam. 17 in. (43.2 cm)
Purchased with funds provided by the George Sidney Trust and
the Decorative Arts Council Fund M.86.151

Pictorially decorated Staffordshire slipware of the late seventeenth cen-
tury represents a vital moment in the history of English pottery and a
decisive break with medieval tradition. Up to this point English presenta-
tion pieces, bowls or platters commissioned as gifts, were generally made
from precious metals, and ceramic ware was merely for common use. But
with these large, thematic, slip-decorated ceramic pieces English pottery
became increasingly sophisticated.

Slipware was produced in London by 1630, largely by Puritan potters
inclined to ornament their work with lugubrious mottos such as Fast and
pray or Remember thy end. The rare Staffordshire wares of Thomas Toft
and William and George Taylor by contrast are notable for their trailed
slip (liquid clay) decoration and dot-outline figures. A versatile medium,
slip can be applied as paint or a dip, trailed, dripped, or applied with a
knife, and incised to expose the contrasting clay body.

Most Toft and Taylor presentation pieces carry a lively decoration of
royalist themes, acknowledging lighter-hearted political times following
Oliver Cromwell's fall. This charger (a large serving dish) depicts Charles
II's famous escape when, having sheltered in a house near the great wood
of Boscobel, he and a Major Careless were advised to hide in the trees to
avoid capture by Cromwell's soldiers. Early next morning the prince and
the officer climbed a dense oak and enjoyed a quiet day picnicking in its
branches while observing the Roundheads vainly hunting for them below.

NICHOLAS LECROUX (attrib.)
Belgium, Tournay, 1733-99
Pair of Potpourri Vases, about 1760
Porcelain, h. 9 in. (22.9 cm)
Purchased with funds provided by Mr. and Mrs. George Boone
and the Decorative Arts Council Fund M.86.100a-b

The imagery of these delicate vases evokes a central decorative and social conceit of the eighteenth century. Here a refined and elegant couple, comfortably dressed in costumes of the period, perch on naturalistic rocks and indulge in what seems to be a well-mannered flirtation. This is the world of ease and intimacy, painted by the rococo artists Antoine Watteau, François Boucher, and Jean Honoré Fragonard, in which the cultured and educated classes of France created gardens of controlled rusticity — an artful grotto here, a wild area there — in contrast to the extreme formality of seventeenth-century gardens, architecture, and the ceremonies and manners of aristocratic life.

Much of French eighteenth-century art celebrates this new ease. The creator of this charming pair of vases has incorporated the rococo notion of elegant entertainment (*fête galante*) into a functional design. The flower-draped neoclassical urns were designed to hold sweet-scented potpourri; their pierced decoration is thus also practical.

Although each vase is self-contained and compositionally balanced, they are meant to be seen as a pair. The two skillfully modeled figures speak across the space between them. Although porcelain figures were extremely popular in the mid-eighteenth century, most were poorly composed and weakly modeled. Together with Johann Joachim Kändler of Meissen and Franz Anton Bustelli of Nymphenburg, Nicholas Lecroux of Tournay was among the few modelers to take the making of porcelain figures beyond the genre of craft and into the realm of fine arts.

CHAMBERLAIN'S WORCESTER
England, about 1786–1852
Dessert Service, 1807–11
Porcelain, various sizes
Ill.: *Dessert Dish, Troilus and Cressida*, act 3, scene 2;
7½ × 10 in. (19 × 25.4 cm)
Gift of Mr. Walter T. Wells, Jr. 58.59.1-38

Ostensibly a dessert service, the thirty-eight pieces in this lavish porcelain set suggest much about its makers and its owners. Produced at the Chamberlain's Worcester porcelain works sometime between 1807 and 1811, the set portrays forty-two scenes from twenty-nine of Shakespeare's plays. Each piece is inscribed with the mark *Chamberlain's Worcester, Manufacturers to their Royal Highnesses, the Prince of Wales and Duke of Cumberland* and bears an identification and quotation from the depicted act and scene.

The set was probably decorated by Humphrey Chamberlain, Jr., from 1807 the head of the Worcester factory established by his family in the late eighteenth century. He developed a flawless technique of painting on porcelain in brush strokes so delicate it was said they could be seen only with a magnifying glass. His virtuosity was likely reserved for the factory's most select productions. In the eighteenth and early nineteenth centuries Worcester porcelain competed with the products of Sèvres in France; this set may have been among the lavish display pieces made to demonstrate the British ware's high quality.

Chamberlain's nephew later recorded that "one small dessert service painted with Shakespeare subjects by my uncle" was purchased by the prince regent for £4000, an astronomical sum in the early 1800s. Whether it was this set is not altogether clear, but only a very wealthy patron could have afforded such a service. A remarkable and beautiful example of Regency taste, the set would have been appreciated rather like a miniature gallery, each piece admired as an individual work of art.

CHEST

United States, Connecticut, about 1700
Pine, 36¾ × 40 × 18 in. (93.3 × 101.6 × 45.7 cm)
Gift of Mr. and Mrs. Murray Braunfeld 60.47.1

Boards almost an inch thick form the drawers of this early eighteenth-century chest, in its time an innovative piece of furniture. From the Middle Ages onward householders had used lidded chests for storage, and their simple forms changed only very slowly. The addition of pull drawers to the lift-top chest was a successful modification, and during the seventeenth century two- and even three-drawer chests were made. Finally cabinetmakers did away with the lidded compartment altogether, creating this type of four-drawer chest, which in use and appearance continues unchanged in modern times.

In many ways this chest cheerfully pretends to a status it does not possess. The once-vivid painted decoration of birds, fleurs-de-lis, and flowers was intended to suggest the elaborate inlaid and japanned designs found on more complicated European pieces. The painted decoration relates to other examples generally attributed to coastal Connecticut.

The chest's construction is both solid and sophisticated. Single dovetails join drawer fronts and sides. Along with the heavy construction and use of side runners to support the drawers, these features suggest an early eighteenth-century date in a period of rapidly changing technology and form.

CLOTHES PRESS
England, about 1760
Mahogany, 87 × 59 × 26¾ in. (221 × 149.9 × 67.9 cm)
Purchased with funds provided by George Cukor and
the Museum Acquisition Fund M.86.54a-b

This imposing chest, until recently considered lost, is one of a pair; its companion is in the Metropolitan Museum of Art. Both were commissioned by a wealthy patron for storing garments or linens in an era before the built-in closet was conceived. The ornamented doors open to reveal banks of drawers. A status symbol of extreme luxury, only the wealthiest clients could afford such elaborate furniture. The identities of the designer and maker of the pair remain a mystery.

Thomas Chippendale (1718-79) is the best-known designer of English rococo furniture, of which this cabinet is an example. His fame was enhanced by publication in 1762 of a pattern book, *The Gentleman and Cabinet-Maker's Directory*. In it Chippendale popularized three styles of furniture: French, Chinese, and Gothic. The idea of deliberately designing objects and furniture in exotic and historical styles caught European fancy in the late eighteenth century and remained popular through the nineteenth.

The design of this chest reveals a self-conscious mix of the three styles. The pointed door arches derive from fourteenth-century English Gothic architecture, but the arch-supporting uprights, or columns, are banded in imitation of bamboo internodes. The delicate woodwork on top of the chest includes interlaced angular panels drawn from an allusive vocabulary of oriental design, while the feet are carved with French rococo motifs.

TABLE WITH VIEWS OF ROME

Italy, Rome, second quarter 19th century
Mosaic and gilded wood, 28½ × 32⅞ in. (diam.) (72.4 × 83.5 cm)
Gift of Mr. and Mrs. Arthur Gilbert M.75.135.15

This curious massive table combines Second Empire (1852–70) taste
with the last manifestation of the art of mosaic. The Renaissance, with its
turning toward secular subject matter, accomplished the divorce of
mosaic from mythological and iconographical subject matter and architec-
tural scale. By the time this table was commissioned, mosaic had become
a pictorial and miniaturized art. Its original materials — the pebbles of
Greek antiquity, the fired tiles of the Mediterranean peoples, the gold-
flecked tesserae of Venice — are here reduced to tiny *smalti*, rectangles of
glass measuring in millimeters and produced in a range of carefully con-
trolled colors. The smooth, almost textureless surface is in effect a paint-
ing that will never crack or fade.

Pieces such as this table were made in Roman ateliers to satisfy the taste
of a new bureaucratic aristocracy for the trappings and scale of empire in
their private salons. These ateliers competed with the kilns of Sèvres,
which produced smooth, elegantly painted pictorial porcelain panels used
to embellish tables and chests.

In these highly mannered mosaic scenes the control of the smalti
palette and the skill of the mosaicist meant total success or total failure. In
the round tabletop format Roman craftsmen tried to perfect a harmonious
balance of pictorial and decorative elements. The compositional struc-
ture of a central roundel theme surrounded by subordinate vignettes, here
a view of St. Peter's Square encircled by twelve Roman monuments, is
typical of this most characteristic of Empire-style furnishings.

HERTER BROTHERS
United States, New York, 1865–1905
Cabinet, about 1880
Rosewood, other exotic woods, glass, mother of pearl,
and velvet; 80×36×24 in. (203.2×91.4×61 cm)
Gift of the 1987 Collectors Committee M.87.158

The brothers Christian (1840–83) and Gustave (1830–98) Herter were German immigrants to New York. In 1865 they established a cabinet-making and decorating firm that attracted wealthy clients in New York, Boston, Minneapolis, Chicago, and San Francisco. This new American upper class, its fortunes founded in commerce, proved eager to demonstrate a cosmopolitan awareness of both history and good taste. Families such as the Rockefellers and Vanderbilts commissioned Herter Brothers to decorate and furnish rooms, even entire houses, with beautifully crafted home furnishings comparable in luxury and cachet with the finest European accoutrements.

In both America and Europe the taste of the late nineteenth century favored historicism and exoticism; decorative arts and architecture quote especially from styles of the Near and Far East. This cabinet typifies both the oriental taste and extraordinary craftsmanship of the so-called aesthetic movement. Its Moorish elements include inlaid star and rosette shapes from Near Eastern tile patterns, the grillework of the drop-leaf door, and the geometric inlay bands framing the panels. The cabinet form recalls Islamic cabinets used from the thirteenth through sixteenth centuries as lecterns for the Qur'an and to store liturgical objects and texts.

From the 1870s onward prestigious Victorian upper-class homes might include elements of Near Eastern design, such as Persian-style "cozy corners" and smoking rooms. This lavishly inlaid cabinet would certainly have suited such an exotic, overfurnished environment.

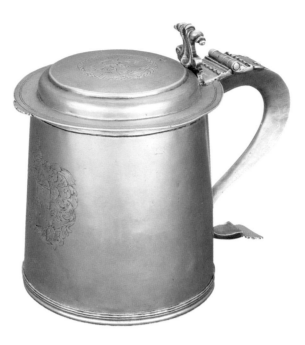

WILLIAM ROUSE
United States, Boston, 1639-1705
Tankard, 1680-92
Silver, h. 7⅜ in. (19.4 cm)
Gift of Florence Alden Stoddard and Katharine Alden Stewart M.86.24

Very little pre-eighteenth-century American silver survives. This finely engraved piece is one of two known tankards by William Rouse, a Dutch-born silversmith active in Boston from the 1670s until his death.

Tankards (large, lidded drinking vessels) were originally popular in Europe and were adopted in England in the seventeenth century. They were commonly given as gifts by the wealthy to mark anniversaries or marriages. Prosperous colonists brought such objects with them to America and used them for domestic, ceremonial, and even religious purposes.

The complex history of this tankard can be reconstructed from physical evidence, but its date of origin and first owner are unknown. Stylistically it could date as early as 1680; its latest possible date is that engraved on the bottom of the tankard, *May 8, 1692*. Rouse marked the cover and body with his maker's impress (*W•R* in shaped shield). The tankard's history is linked to the Alden family, descendants of John and Priscilla Alden of the Massachusetts Bay Colony. The tankard descended in the Eliot branch of the Alden family; the initial *E* over *AR* on the handle may commemorate the marriage in 1707 of Andrew Eliot and Ruth Symonds, whose descendants donated the tankard to the museum. The prominent coat of arms on the tankard's body has never been identified but is a beautiful example of Rouse's skill as an engraver, as is the sunflower on the tankard's lid.

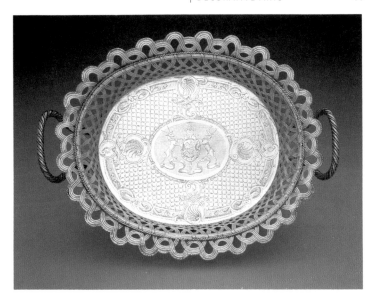

PAUL DE LAMERIE
England, 1688-1751
Basket, about 1731
Silver, 4×15×11 in. (10.2×38.1×27.9 cm)
Marks: London, Britannia Standard, 1731-32;
maker's mark of Paul de Lamerie
Gift of Mr. and Mrs. Arthur Gilbert M.75.135.49

This silver basket was made for Sir Robert Walpole, first earl of Orford (1675-1745), and is engraved with his coat of arms impaling that of his wife, Catherine, daughter of Sir John Shorter. Walpole, first prime minister of England, was one of Paul de Lamerie's leading patrons during the 1720s and 1730s, and a number of important pieces with his coat of arms survive by this maker.

Paul de Lamerie was perhaps the most original and brilliant of English eighteenth-century goldsmiths. His work, made for some of the wealthiest patrons of the day, is invariably of outstanding quality, although he was best known during his lifetime for his highly innovative rococo silver, in a period when sophistication, wit, and artifice dominated artistic sensibility and patrons' tastes.

The silver bread basket was a popular rococo form and was the vehicle for some of de Lamerie's most original designs. This basket, an early example, is one of at least eight similar pieces supplied by him to different clients. De Lamerie has imitated basketry elements with plaited wickerwork in the flared sides, reed and tie on the foot and rim, and twined ropework and cording on the handles. In the hands of a lesser artist they might have declined into mere whimsy, but de Lamerie has created here a masterful and elegant unity. The trellis and asymmetrical scrollwork surrounding the coat of arms are the chief rococo features of the basket's style, but the lightness of spirit of rococo design and ornament is inherent in the very idea of imitating humble wickerwork in precious silver.

LOUIS COMFORT TIFFANY
United States, 1848-1933
Tiffany Studios, New York, 1902-33
Tea Set, 1902-4
Sterling silver; teapot: 6¼ × 5⅞ × 7⅝ in. (15.9 × 14.9 × 19.4 cm),
sugar bowl: 3¼ × 5⅜ in. (diam.) (8.2 × 13.6 cm),
creamer: 4 × 4⅛ × 5⅛ in. (10.2 × 10.5 × 13 cm)
Purchased with funds provided by the Director's Roundtable M.85.3a-c

Louis Comfort Tiffany was the most famous American artist to work in the late nineteenth-century art nouveau style. The movement was conceived by artists attempting to form a new vocabulary of style in decorative arts in reaction to the Victorian taste for historical styles cast in pseudo-Gothic or classical terms. Proponents of art nouveau also wanted to eliminate distinctions of class between "high" art — painting, sculpture, architecture — and "craft" and so applied their energies equally to the design of jewelry and furniture.

Art nouveau artists and craftsmen included Henri van de Velde, René Lalique, and Charles Rennie Mackintosh. Having cast out derivative Victorian styles, they developed a new decorative vocabulary from sinuous vines, flowers, and Eastern motifs. This exotic tea set is composed of overlapping pointed forms recalling lotus forms in the Mughal arts of India. Their shapes, also suggesting feathers or insect wings, two favorite art nouveau motifs, embody a visual ambiguity valued by the movement.

Tiffany produced very little silver, perhaps because he wished to distinguish himself from his father's silver and jewelry firm. The son is best known for lamps, glass, windows, mosaics, and bronzes. He produced silver only on commission; fewer than twenty-four pieces survive. He designed this tea service for his own home, Laurelton Hall, the fabulous estate he designed and furnished from 1903 to 1904 in Oyster Bay, Long Island. This rare set illustrates the spare, elegant rhythms of art nouveau design and the energy that its advocates applied to the production of precious but functional objects for the home.

EUROPEAN PAINTING AND SCULPTURE

ANDREA DELLA ROBBIA
Italy, Florence, 1435-1525
The Annunciation, about 1475-80
The figures of God and the dove may be by another hand.
Lead-glazed terra-cotta; Virgin: h. 65 in. (165.1 cm),
Archangel Gabriel: h. 62 in. (157.5 cm),
God the Father: 17½ × 16½ in. (44.5 × 41.9 cm) [not illustrated],
Dove of the Holy Spirit: 6 × 11 in. (15.2 × 27.9 cm) [not illustrated]
William Randolph Hearst Collection 47.8.1a-d

Developed by Luca della Robbia, glazed terra-cotta sculpture was used
where light was insufficient to bring out marble's more subtle qualities or
where color accents were required. The medium gained great popularity
in fifteenth-century Florence and became a specialty of the della Robbia
family studio, which was directed by Andrea after Luca, his uncle, died.

This Annunciation group has the solemnity and grace typical of the
last years (1450-60s) of the early Renaissance in Florence. Discovered in
the small Florentine church of San Nicolo, the figures were probably
made for a private chapel in the Bardi Palace, where they would have been
placed at some distance from each other, perhaps flanking an altarpiece or
spanning an architectural space.

The entire group consists of Mary, the archangel Gabriel, God the
Father, and the dove of the Holy Spirit. Mary's downcast eyes and hand
across her breast indicate she is accepting the Incarnation with pious
humility. She is depicted with the refined features and graceful rhythms
that late fifteenth-century artists used to suggest spiritual worthiness.
Her lowered right hand points to the triangular drapery folds covering
her womb, a reference to the tabernacle of Christ. Gabriel's wide stance,
legs bent as if to kneel, reflects his swift arrival and the urgency of
his momentous message.

The serenity and simplicity of the group, combined with the skillful
articulation of the bodies and the carefully observed naturalism of both
the dove's and the angel's wings, readily conveyed the fundamental
doctrine of the Annunciation to worshipers of the fifteenth century.

ROSSO FIORENTINO
(Giovanni Battista di Jacopo di Guasparre)
Italy, Florence, 1494-1540
*Allegory of Salvation with the Virgin, the Christ Child, Saint Elizabeth,
the Young Saint John, and Two Angels*, about 1521
Oil on panel, 63½ × 47 in. (161.3 × 119.4 cm)
Gift of Dr. and Mrs. Herbert T. Kalmus 54 6

Rosso Fiorentino was trained in the Florentine High Renaissance tradi
tion, with its emphasis on beauty, balance, and harmony, but as an early
mannerist artist in revolt against Leonardo, Raphael, and other masters,
he deliberately avoided repose, classical symmetry, and rational anatomy
in his paintings.

The most probable subject of this painting is a narrative popular in
early sixteenth-century Florence in which the Christ Child, meeting the
young John the Baptist, foretells their futures: that John will baptize him
and that Jesus will be crucified. In Rosso's version John's bent and aged
mother, St. Elizabeth, has prophesied Jesus' terrible fate. She and Mary
share deep distress at the revelation, while Jesus reaches inside his
mother's garment, a traditional gesture indicating his need for sustenance
and protection in his vulnerable human state. At the dire news the boy
John has fallen down as if dead. Above, two angels respond to the scene
with expressions of anguish.

Mannerist artists often quoted other works of art, and here Rosso
portrayed the boy John in a posture reminiscent of the dead Christ in
Michelangelo's *Pietà*, a source easily recognized by viewers of the day.
The figures have no clear location, and their scale is ambiguous, the ovoid
composition compressing all the various emotional reactions into one
narrow plane. Not concerned with developing personalities or corporeal-
ity, Rosso abstracted the figures to project an intensely personal insight.
His rapid application of paint, more noticeable because the painting is
unfinished, reinforces the work's uneasy urgency and visionary quality.

ANNIBALE FONTANA
Italy, Milan, 1540(?)-87
Adoring Angel, 1583-84
Wax with metal armature on wood base,
h. (with base) 21¾ in. (55.2 cm)
Gift of The Ahmanson Foundation M.80.191

This angel is a rare wax model for one of five figures commissioned for the pediment of the church of Santa Maria presso San Celso in Milan. Conceived in a late Renaissance style influenced by Michelangelo and Guglielmo della Porta, the models were made for the approval of church officials by the artist Annibale Fontana before he began to carve the figures from expensive marble blocks. The group included a Virgin of the Assumption flanked by two mirror-image adoring angels and a similar pair of trumpeting angels. Fontana finished the marble Virgin and the trumpeting angels before his death in 1587, but the pair of adoring angels was executed three years later by Vimercati, another Milanese sculptor. Although they are now badly weathered, it appears Vimercati's marbles did not do justice to Fontana's conception in wax.

The bodily assumption of the Virgin Mary into heaven was a subject important to the church, for it attested Mary's virtue, her worthiness to be Christ's mother, and her lifelong faith. Fontana's adoring angel underscores the significance of the event. Sweeping backward, his light, classicizing garment exposes one knee, articulating a forward momentum that, seen in the pair of figures, would visually reinforce the image of the Virgin's being drawn up into heaven.

In the marble version the two well-formed loops of drapery swinging from below the angel's shoulders provided stable supports for metal wings. Although indisputably an angel, the figure's humanized and emotional response to the Virgin guided the worshiper's contemplation of the miracle of her assumption.

ARCHANGEL RAPHAEL
Italy, Naples, about 1600
Polychromed and gilded wood, h. 70 in. (177.8 cm)
Gift of Anna Bing Arnold M.77.52

During the Renaissance the role of angels in daily life was taken quite seriously. They were discussed in sermons and appeared in visions to many of the great religious reformers of the age. In Naples the archangel Raphael was considered a special patron of seafarers.

This figure's graceful beauty and slender proportions link it with the late Renaissance (1550–1600), or mannerist, style. Its elaborate surfaces and swaying movement also suggest the influence of the Spanish Hapsburgs, who ruled Naples at that time and cultivated a taste for elaborate wooden icons. The technique used to color the angel's tunic imitates brocade by scratching through paint applied over gold leaf and had been common in Spain for centuries.

There is evidence that this figure of Raphael was once accompanied by that of Tobias. The Book of Tobias in the Apocrypha tells of a beautiful young man, actually Raphael, who offered to travel with Tobias on his first journey away from home to recover a debt owed his poor, aged father. With the angel's care and instruction, Tobias met and overcame many hazards.

This work expresses those aspects of the story most reassuring to an Italian merchant patron. Raphael's gaze is solicitous; his upward-pointing hand indicates his divine mission. His sandals, girdle, and tunic recall Roman military dress, a reminder that this is no mortal but a powerful paladin of Christ. While his stance and backward-flowing drapery can be read as a forward stride, the angel's body is not thrust forward, and the edges of his elaborate robes curl up unexpectedly, creating the sensation that he is surrounded by the "spiritual wind" that indicated special holiness in earlier Christian art.

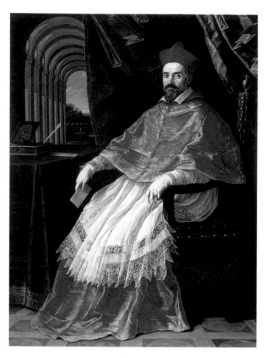

GUIDO RENI
Italy, Bologna, 1575-1642
Portrait of Cardinal Roberto Ubaldino (1581-1635),
Papal Legate to Bologna, before 1625
Oil on canvas, 77½ × 58¾ in. (196.9 × 149.2 cm)
Gift of The Ahmanson Foundation M.83.109

Guido Reni studied at the influential Carracci Academy in Bologna, a school that expounded a style uniting the painterly characteristics of the great masters of the preceding generation, among them Raphael, Tintoretto, Titian, and Correggio. Like them, Reni drew on history, mythology, and religion for subjects for his narrative paintings, the kind most prestigious and in demand during his time. Nevertheless he completed several portrait commissions; his depiction of Cardinal Roberto Ubaldino is one of only a few portraits by major seventeenth-century Italian artists.

The cardinal's pose is traditional, established by Raphael's and Titian's earlier portraits of popes. In its clear and carefully balanced composition the work emulates Raphael, Reni's idol, yet Ubaldino is not idealized. Reni's desire for classical perfection is balanced by a seventeenth-century literalness that attempted a faithful transcription of the cardinal's physical and psychological presence.

A cousin of Pope Leo XI and an envoy of Pope Paul V, Cardinal Ubaldino, a subtle and astute diplomat, was papal nuncio to Paris during the Huguenot intrigues of the early 1620s. Through the architectural treatment of the background draperies, the elaborate texturing and pyramidal stacked shapes of the garments, and the palpable depiction of the cardinal's features, Reni conveys Ubaldino's forceful personality and strength of character. At the left, the rhythmic arches of the loggia rapidly recede to a view of the cardinal's garden and the outside world, reinforcing the artist's interpretation of him as a man of affairs.

REMBRANDT HARMENSZ VAN RIJN
Holland, 1606–69
The Raising of Lazarus, about 1630
Oil on panel, 37⅞ × 32 in. (96.2 × 81.3 cm)
Gift of H. F. Ahmanson and Company in memory of
Howard F. Ahmanson M.72.67.2

Throughout his life Rembrandt sought to depict the stories and parables of the Old and New Testaments in accessible, familiar images. Because the Dutch Reformed Calvinism of his time forbade religious art in churches, public painting commissions for scriptural subjects were virtually nonexistent, but an enthusiastic private patronage for them thrived, which helps account for the preponderance of religious subjects in Rembrandt's work.

The Raising of Lazarus is Rembrandt's only painting of this subject, the miracle marking the culmination of Christ's ministry (he also made drawn and etched versions). Christ's divine and human nature is revealed as he stands in the burial cave, his hand raised to perform the miracle, his face filled with apprehension and strain. Rembrandt interprets Lazarus's rising not in direct correspondence with Christ's forceful gesture but rather in response to the subtle power it has unleashed.

Around Christ and the grave huddle the astounded witnesses — among them Mary and Martha, Lazarus's sisters — whose gestures and expressions record successive states of awareness at what is unfolding. The strong light from the cave entrance suggests but does not fully symbolize spiritual presence, as it does in Rembrandt's later work.

The objects in the beautiful still life of helmet, scabbard, and quiver and the Near Eastern garb of the man in red are from the artist's large collection of exotic accessories and costumes. They help establish the event's distant time and place, while the then-contemporary dress of Mary links the scene to Rembrandt's time, affording an intimate appreciation of this miraculous event.

ANTHONY VAN DYCK
Flanders, 1599-1641, active in Italy and England
Andromeda Chained to the Rock, 1637-38
Oil on canvas, 84¾ × 52 in. (215.3 × 132.1 cm)
Gift of The Ahmanson Foundation M.85.80

In 1621 Anthony van Dyck left Antwerp and his position as chief assistant to Peter Paul Rubens. He spent the next six years in Italy, conceiving a passionate admiration for Titian and developing a mature painting style. He lived in England from 1632 until his death, becoming a fashionable portrait artist and court painter to King Charles I.

Van Dyck's cultural milieu and pictorial style emerge in this painting of Andromeda, the beautiful Ethiopian princess whose sacrifice was required to placate a sea monster ravaging the kingdom. Van Dyck depicts her chained in a rocky grotto awaiting her fate while the monster approaches through the waves. Perseus, her rescuer, hastens through the skies on Pegasus. Ideals of medieval chivalry were so much a part of English court ceremony at this time that Perseus's appearance in full contemporary armor would have seemed perfectly appropriate to van Dyck's aristocratic audience.

Both Rubens's and Titian's depictions of Andromeda influenced van Dyck. He owned the work by Titian and from it borrowed Andromeda's stance. She stands firmly, full-length and life-size, in a contrapposto pose, gazing up in anguish. Like Rubens's Andromeda she has a solid physical presence, which may also stem from the fact that van Dyck's mistress and model Margaret Lemon posed for the painting. The figure's lively eyes, distinct facial features, and subtle modeling of flesh tones reveal the artist's concern for surface texture and pattern, the hallmarks of his style. His brush strokes vary to soften the background and rock and to enhance the tactile quality of Andromeda's skin and drapery.

GEORGES DE LA TOUR
France, 1593-1652
Magdalen with the Smoking Flame, about 1640
Oil on canvas, 46×36⅛ in. (116.8×91.8 cm)
Gift of The Ahmanson Foundation M.77.73

Although Georges de La Tour spent his entire artistic career in provincial France far from cosmopolitan centers and artistic influences, he developed a poignant style as profound as the most illustrious painters of his day. In his lifetime his work appeared in the prominent royal collections of Europe. La Tour's early training is still a matter for speculation, but in the province of Lorraine he encountered the artist Jean Le Clerc, a follower of the Italian painter Caravaggio. From this source likely came La Tour's concern with simplicity, realism, and essential detail.

Mary Magdalen was traditionally depicted in her grotto or as an aged woman. The absence of explicit narrative in this painting emphasizes Mary's state of mind and heart rather than time and place. The simple composition of vertical and horizontal shapes draws the viewer into the Magdalen's contemplative world. The skull, books of Scripture, and scourge set the mood, but the chief symbol and true subject of the work is the candle at which Mary gazes in her meditation. Rendered in extraordinary detail and modulation, it emits the light that followers of St. John of the Cross called "the living flame of love," toward which spiritual pilgrims are drawn out of the "dark night of the soul."

La Tour scrupulously conveys the tactile quality of surfaces. The polished skull and leather books have different reflective qualities; Mary's heavy skirt, thin, wrinkled blouse, smooth flesh, and hair are meticulously distinct. Each spare detail is carefully regulated to achieve an overall balance of form and light.

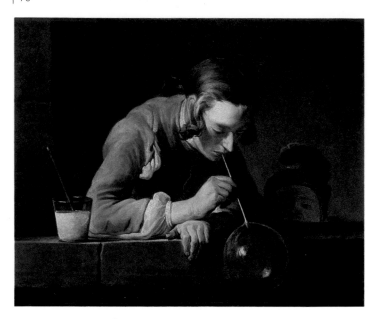

JEAN-BAPTISTE SIMÉON CHARDIN
France, 1699-1779
Soap Bubbles, after 1739
Oil on canvas, 23⅜ × 28¾ in. (60×73 cm)
Gift of The Ahmanson Foundation M.79.251

Jean-Baptiste Siméon Chardin's work gained public attention just as a reaction to the painterly and thematic excesses of rococo art was setting in. He was admitted to the French Royal Academy as a still-life painter in 1728, a rare honor, as still life was then esteemed far less than paintings of historical, mythological, or courtly subjects. Even though his work reflected the ordinary images, decorum, and morality of the bourgeois life from which he came, Chardin's talents were recognized in exalted artistic and aristocratic circles.

Chardin began to paint genre subjects in the late 1730s, evoking through his observation of everyday life a contemplative atmosphere that in France had largely remained the domain of religious painting. In some ways his painting heralded the values of the art criticism of the Enlightenment, with its emphasis on rational content, naturalistic imagery, and qualities of truth and directness in subject matter.

Soap Bubbles is carefully composed in the simplest of geometries, with the window forming a rectangular space to frame the pyramidal grouping of the youth and the boy transfixed by the spherical bubble; these primary orders and shapes are reinforced by the masonry, angles of the youth's arms, and the pair of heads. Chardin renders surfaces carefully but without distracting detail. He employs effects of light to assert the individuality of his subjects as well as their relationship to the painting as a whole. His techniques create a feeling of timeless contemplation, as, with simplicity and concentration, the artist dignifies the ephemeral pastime of the pair.

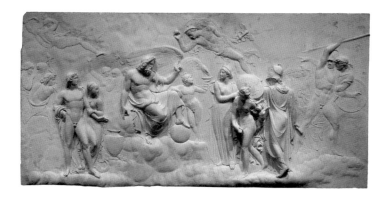

JOHN DEARE
England, 1759-98, active in Italy
Judgment of Jupiter, 1786-87
Marble relief, 58¼ × 117¼ in. (148 × 297.8 cm)
Gift of Anna Bing Arnold M.79.37

John Deare, an English sculptor who spent his entire professional career in Rome, was commissioned by the Royal Academy to make this relief for an exhibition in 1787. In style and subject matter it reflects neoclassical aesthetics and canons of perfection. The philosophers of the Age of Reason believed that man and society, through the systematic study and emulation of both classical learning and arts, could return to the Golden Age of antiquity. Deare's relief embodies this ideal.

Deare's scene is from Homer's *Iliad*, a source for which contemporary archaeological discoveries had created new interest. The enthroned Jupiter sits among the immortals, guests at the wedding of Peleus and Thetis (at left), to which all except the goddess of discord, Eris, were invited. The spiteful Eris tossed a golden apple inscribed "to the fairest" among the guests, and Minerva, Juno, and Venus each claimed it. Jupiter, refusing to pick the fairest of this formidable trio, has handed the apple to Mercury (above) with instructions to pass it, and the thankless task, to Paris. In an innovative departure from Homer's narrative, Deare depicts the three goddesses anticipating Paris's judgment, an action which indirectly led to the Trojan War, here evoked by Mars, god of war (far right).

Deare's carving varies from a subtle modulation of background figures to nearly full round, a Renaissance technique that gives the illusion of three-dimensional space. His body forms are idealized, smooth, and refined, lacking the sinewy organic presence of their classical prototypes, but Deare's contemporaries would have seen them as true inhabitants of Olympus.

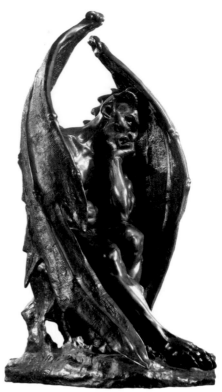

JEAN-JACQUES FEUCHÈRE
France, 1807-52
Satan, about 1836
Bronze, h. 31 in. (78.7 cm)
Purchased with funds provided by the Times Mirror Foundation M.77.45

Jean-Jacques Feuchère's public commissions are characterized by a restrained academic style. Well received by the conservative artistic establishment of Paris, his work was accepted by the Salon juries, the contemporary arbiters of taste. Feuchère's sculpture suggests his interest in the history of art and style; it is said that some of his jewelry designs passed as actual Renaissance work. His versatility in technique and manner was labeled an "exasperating universality" by his friend the poet Charles Baudelaire. In this conception of Satan, however, Feuchère created an original and influential masterwork.

The figure of Satan, semihuman and cursed, haunted the romantic imagination of the nineteenth century and attracted contemporary taste for the bizarre. Feuchère's treatment of the fallen Lucifer, brooding and isolated within the shelter of the leathery folds of his batlike wings, may have been influenced by the romantics' tendency to identify the artist as a being beyond the pale of ordinary society.

This composition takes its pose from Dürer's *Melancholy*; Feuchère owned a copy of the print. Its face may refer to a Notre Dame gargoyle made famous in nineteenth-century engravings, and its body recalls Delacroix's *Mephistopheles in the Air*, an illustration to Goethe's *Faust*, but the disturbing synthesis is uniquely Feuchère's. Ironically, this image inspired Rodin's *The Thinker*; the contrast between *Satan*'s vacant despair and *The Thinker*'s ennobling and self-conscious intellect could hardly be more profound.

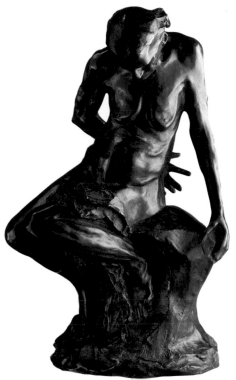

AUGUSTE RODIN
France, 1840-1917
She Who Was the Helmet-Maker's Beautiful Wife, about 1880-85
Bronze, h. 19½ in. (49.5 cm)
Gift of Iris and B. Gerald Cantor M.84.164

The title of this work refers to a fifteenth-century ballade by the French poet François Villon in which an old woman laments her lost youth and beauty. But Rodin did not intend to illustrate this specific poem; he also exhibited the work under the titles *The Old Courtesan* and *The Old Woman and Winter*.

This bronze figure is fundamentally shocking; its subject, the change wrought by time on human flesh, is a theme that resonates throughout Rodin's work. Of ugliness and age, Rodin wrote: "What is commonly called *ugliness* in nature can in art become full of great beauty," a statement emphasizing the transforming vision of the artist. Here the ravaged body of an elderly woman with flat breasts, pendulous belly, and bony pelvis sits in a grotesquely twisted posture, one arm behind her, emphasizing Rodin's intent to expose her fully. Her left foot and leg emerge from the matrix of the object on which she sits, as if making an ironic allusion to the unaging tree-dwelling dryads of classical mythology.

This image also appears in Rodin's unfinished masterwork, *The Gates of Hell*, an enormous doorway containing imagery based on Dante's *Inferno* and commissioned in 1880 for the proposed Museum of Decorative Arts in Paris. Although the museum was never built, Rodin worked on the doors, the consummate statement of his artistic outlook, for the rest of his life. They were the source for countless images and figures. As part of the doors *The Helmet-Maker's Wife* takes on a more iconic and traditional meaning; there she illustrates the sin of vanity.

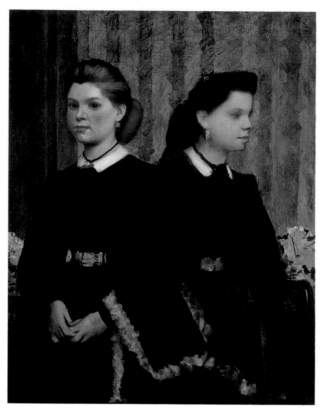

HILAIRE-GERMAIN-EDGAR DEGAS
France, 1834-1917
The Bellelli Sisters, 1862-64
Oil on canvas, 36¼ × 28½ in. (92 × 72.4 cm)
Mr. and Mrs. George Gard De Sylva Collection M.46.3.3

Between 1856 and 1860 the young Edgar Degas spent a good deal of time in Italy, where he studied Old Masters and visited his Italian relatives. Giovanna and Giulia Bellelli, his first cousins, were children of a maternal aunt and Baron Gennaro Bellelli, a political revolutionary exiled to Florence from his native Naples between 1849 and 1860. Degas's numerous studies of the family members culminated in an incisive work, *The Bellelli Family*, executed in Paris in 1860. As much a social document as a family portrait, it reveals tensions and estrangement between the parents while contrasting the reserved Giovanna with her livelier younger sister.

Degas was extraordinarily sensitive to the way stance, gesture, and expression reveal psychological states. He painted *The Bellelli Sisters* after the family, their fortunes restored, had returned to Naples. Whether because they are older or the family more prosperous, both girls seem here more prosaic and complacent than in earlier works. Giovanna faces forward with averted gaze and nervous fingers; Giulia has acquired a closed, set expression. Degas has emphasized their family resemblance while evoking their introspection, but the sisters remain individuals, expressing different aspects of a shared experience. Their formal pose and stillness relate to older conventions of painting as well as to popular daguerreotype portraits of the time. As in a photograph, values change subtly and focus recedes with distance.

FAR EASTERN ART

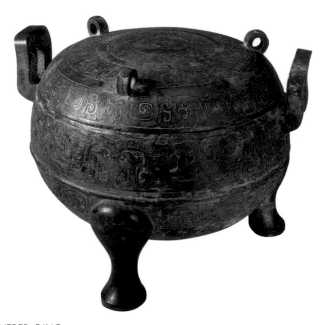

COVERED *DING*
China, late Zhou dynasty, first quarter of the 5th century B.C.
Bronze, 13½ × 15½ in. (34.2 × 39.3 cm)
Gift of Mr. and Mrs. Eric Lidow M.74.103

The *ding*, a three-legged ritual vessel whose origins predate the legends and cloudy early history of the Shang dynasty (about 1523-1028 B.C.), was used to hold food offered to ancestral spirits. The ding was also a ground for ornament. Fantastic creatures, symbols, even written characters recording ritual procedures were cast into its surface.

In its typical Shang form, the ding was a sturdy, lidless vessel mounted on straight legs. Contact with other cultures introduced new elements in its shape and ornament as well as new uses. By the time of the Eastern Zhou dynasty (770-256 B.C.) the ding had acquired the refined form in which it appears here. It had also been secularized; although the Shang tradition of burying bronzes with the dead continued, they were also presented as state gifts to foreign rulers and preserved and handed down as symbols of family honor and status.

The Lidow ding is related stylistically to a cache of fine bronzes discovered near the village of Liyu (northern Shanxi province) in 1923. It exemplifies the high level of bronze casting attained by Eastern Zhou metalsmiths despite the anarchy and constant warfare that plagued the period. The animal forms of an earlier era have become finely stylized and abstracted; an interlace of zoomorphic and geometric elements covers the entire surface of the ding's body and lid. The curvilinear pattern in an overlapping two-layer relief contains forms suggestive of rams, birds, and felines. Restless spirals, S-curves, triangles, and scales are composed in ribbonlike bands. On the "knee" of each cabriole leg is an inlaid animal mask, an image from earlier ding forms.

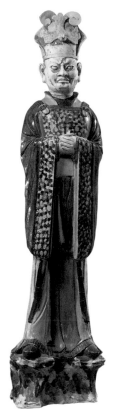
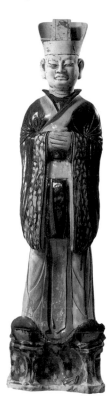

PAIR OF OFFICIALS
China, Tang dynasty (618–907)
Polychrome-glazed pottery, h. 47 ½ in. (120. / cm)
and 45 ¼ in. (115 cm)
Gift of Leon Lidow M.75.77.1-2

The interment of ceramic figures with the dead was widely practiced in the Tang period (618-907), but the number and kinds of objects were strictly controlled in accordance with the social position or political status of the deceased. With imposing demeanor and resolve these two figures represent the dignity of a nobleman. They were once placed in a tomb containing a panoply of ceramic replicas of officials, guardians, household retainers, animals, utensils, and courtesans, all intended to accompany the deceased in the afterlife.

The scale of these unusually large sculptures, of a white clay body glazed with the familiar greens and ochers of Tang funerary figures, is one indication of the dead nobleman's high rank. Their costumes— embroidered sleeves, long skirts and sashes, elegant shoes — are courtly; the left-hand figure is military, identified by the tabard buckled over his shoulders. Each man stands on a rocklike pedestal, also a sign of rank, as are their headdresses.

In keeping with their roles, the figures bear stern, somewhat remote expressions. Their full-fleshed faces, bowed mouths, aquiline noses, elongated ears, and (in the military figure) glaring eyes are traits that, greatly exaggerated, also appear in representations of guardian figures possessing extraordinary powers. Their vigor and realism exemplify the nature of the Tang dynasty, an era of political stability, artistic achievement, and economic growth.

BLUE AND WHITE PLATE

China, Yuan dynasty, 14th century
Porcelain painted with underglaze cobalt blue, diam. 17⅝ in. (44.8 cm)
Francis E. Fowler, Jr., Foundation and the Los Angeles County Fund 55.40

First introduced in the Yuan dynasty, blue and white ceramic ware was immediately successful and soon dominated the export market; demand for it spread rapidly. A plate of this design and size was probably made for the Near Eastern market and would have been used on formal or ritual occasions, given as a gift, or awarded for services. It is typical of early blue and white Yuan ceramics, with its foliated rim, unglazed base, and freely drawn wave motif. The technique of blue underglaze with white reserved areas, all with a clear feldspathic overglaze, emerged from innovative Yuan ceramic experiments.

The feathery wave motif circles the plate's rim. Three additional concentric tiers of waves give the plate's surface a lively and unpredictable pattern. The two middle wave tiers are interrupted by six lobed "cloud-collar" patterns, which echo the rim shape. Designs in the cloud collars include lotuses, abstract foliage, melons, grapes, bamboo, and morning glories. Some scholars believe the cloud-collar shape derives from designs in Persian metalwork or Mongol and Tatar embroideries; others suggest that it derives from Buddhist designs representing the four cardinal directions.

While the overall program of the plate's design is Islamic in taste, its primary motifs are Chinese. For example, the center medallion's eight partitions contain auspicious Buddhist symbols and the medallion itself represents the Buddhist Wheel of the Law. Underneath the rim is a Near Eastern scrolling floral design of lotus or aster blossoms alternating with pomegranates.

OVAL TRAY

China, Yuan dynasty, 14th century
Carved red lacquer on wood, 9¼ × 6⅜ in. (23.4 × 16.1 cm)
Gift of Mr. and Mrs. John H. Nessley M.81.125.1

The elaborate scene on this small tray depicts a conventional gathering of literati who have just finished a sociable banquet. Within the pavilion a guest nods over the laden table; at left, another departs, followed by a servant bearing a *qin*, a Chinese stringed instrument. The artist delighted in natural forms, as seen in the pine, flowers, planes and contortions of the rockery, in the perspective of the pavilion's facade and the furnishings within (the remains of food are shown in the dishes), and in the band of *lingzhi* mushrooms on the border. His skill in carving and pleasure in patterning pervades the entire plate. The background diaperwork of rosettes and meanders represents earth and sky.

Lacquer objects were made in China, Japan, and Korea from before recorded history; Chinese palace walls dating to the fourteenth century B.C. bore lacquer decorations. Laboriously purified from the sap of a sumac (*Rhus verniciflua*), lacquer can carry several pigments, but red, black, or a combination were used most frequently. Techniques for ornamenting the surface of lacquerwork are numerous and complex, but most often the lacquer is applied over a plain or carved wood core, each coat requiring a long period of careful curing, until the wood is completely covered. The built-up lacquer surface can also be carved. Lacquer has extraordinary adhesive qualities; once cured, it is virtually impervious to moisture, alcohol, food acids, or decay.

DAOJI (Shitao)
China, 1642–1707
Album of Landscapes, (leaf 2 of 8) Qing dynasty, dated 1694
Ink and color on paper, 11 × 8¾ in. (28 × 22.2 cm)
Los Angeles County Fund 60.29.1

The Qing dynasty in China was founded in 1644 by a coup d'etat. Having been asked to come south to Beijing to help quell a rebellion, the Manchus of the north obliged, then occupied the capital and proclaimed their rule. Fortunately they greatly admired Chinese culture, adopting its more conservative institutions and a reactionary Confucianism. Despite this, and despite a period of civil unrest and political realignment, ceramics, architecture, and painting flourished.

This vigor in Qing arts is nowhere better seen than in the work of Daoji, one of the most original and formally creative artists in all Chinese painting. A descendant of Ming royalty, Daoji was an accomplished calligrapher, poet, painter, and art theorist. Although ordained a Buddhist monk, he chose travel over seclusion and enjoyed intellectual and aesthetic relationships with other artists and poets.

Daoji maintained a determined and articulate independence from the academicism that governed literati painting at the time. His painting of the early 1690s shows him at the height of his powers and engaged in experimental stylistic concerns. This scene of Mount Huang depicts white-water rapids at lower left, suggesting a possible viewpoint just in front of the picture plane. Daoji then evokes a great and precipitous leap across a mist-filled chasm to a higher view of steeply massed peaks, a mountain ridge, and a trail where three figures meet, their scale and detail seeming to contradict the implied distance. There is an arresting invention in this shifting perspective. Daoji's fluid washes, dark brush strokes, and voids create solid, naturalistic forms seen in a transient moment.

SOKAN
Japan, 16th century
Mountain Landscape, Muromachi period, mid-16th century
Hanging scroll, ink and color on paper; 32¾ × 15⅜ in. (83.2 × 39.1 cm)
Purchased with funds provided by the Far Eastern Art Council M.76.133

This reflective, somewhat romantic landscape is rendered in the tradition of monochromatic ink painting established in Japan by Tenshō Shūbun in the early fifteenth century and continued a century later in the work of the painter Gakuō Zokyū. Pale touches of red and yellow enhance its lyrical quality.

Paintings of scholars or philosophers living in seclusion, surrounded by remote pinnacles, tall pines, waterfalls, and mists, with no company except that of country people, reflect ideals familiar in Western literature and painting of the eighteenth and nineteenth centuries. These themes of isolation, reflection, and simplicity are conventions that Japanese artists and scholars, emulating the life-style and aesthetic preoccupations of their Chinese mentors, readily adopted. But distinctly Japanese elements appear in this work. The paintings of Gakuō have influenced it most strongly, as is evident in the high distant peaks standing alone in the landscape, the strong tonal contrasts, the axe-cut brush strokes on the textured rocks, the preoccupation with atmospheric voids, and a flat, two-dimensional presentation of the three levels of the painting.

The composition's arbitrary scale, verticality, and contrast of land masses with voids suggesting mists date it to the end of the Muromachi era (mid-sixteenth century). Unsigned except for the seal reading "Sokan," this painting appears to be the artist's only known work.

ITŌ JAKUCHŪ
Japan, 1716–1800
Rooster, Hen, and Hydrangea, Edo period, 18th century
Hanging scroll, ink and color on silk; 54⅞ × 33⅝ in. (139.4 × 85.4 cm)
From the Shin'enkan Collection, Los Angeles County Museum of Art
L.83.50.1

"I paint only what is real and true," Itō Jakuchū inscribed on one of his paintings to account for his meticulous observation of nature. Jakuchū was the eldest son of a prosperous Kyoto grocer, a member of the rising middle class that attained literacy and respectability during the seventeenth and eighteenth centuries. In his late thirties Jakuchū turned from the comforts of his position in society to devote himself wholly to painting. He studied Chinese artists of the Song (960–1279) and Yuan (1271–1368) dynasties as well as flower and bird paintings of the sixteenth-century Japanese Kanō school, and his painting relates to Ogata Kōrin's accomplished and decorative work. A solitary man, Jakuchū worked with little or no connection with other artists. His painting soon became highly individualistic.

Jakuchū maintained a collection of domestic fowl, which he studied and drew compulsively. In this painting he observed a courting cock in full display before a hen. Their feathers are delineated with a realism that goes far beyond general observation. Through his delight in pattern, Jakuchū achieved a flatness of picture plane; there is no recession of space in this work. The hydrangea blossoms reach to the left, repeating the arch of the cock's erect tail feathers and balancing the dense composition where the hen crouches before massive shrubbery stems. Each floweret becomes part of the controlled but moving pattern of each blossom head. The heads shift and build into a larger pattern in contrast to the elaborate stasis of the birds' plumage.

SUZUKI KIITSU
Japan, 1796-1858
Seashells and Plums, Edo period, 19th century
Hanging scroll, color on silk; 13⅜ × 11½ in. (34.6 × 29.2 cm)
From the Shin'enkan Collection, Los Angeles County Museum of Art
L.83.50.64

Suzuki Kiitsu began his studies and painting apprenticeship in a fairly orthodox way. His father's profession, textile dyeing, stimulated Kiitsu's early interest in design and art. The Sakai family, his patrons, introduced Kiitsu to the great Rimpa painter and teacher Sakai Hōitsu, who took him as a pupil at age eighteen. Subsequently Hōitsu saw to it that his talented young disciple studied poetry and the tea ceremony, married advantageously, and was adopted, for purposes of advancement, into the Suzuki family, who also had connections with the influential Sakai. Kiitsu became a samurai and the Sakai family chamberlain, a position enabling him to enjoy the best of several worlds — the social flexibility of the merchant class, sponsorship of a great artist, patronage and stipend of a samurai, and permission to continue his aesthetic training — all somewhat mutually antithetical pursuits in the more rigid Japanese society of only three generations earlier.

Kiitsu worked in the classical Rimpa school tradition, with decorative pattern and bold colors. Some of his work also reflects the topical subjects of ukiyo-e painting, but his main achievement lies in his precise rendering of natural forms: branches or foliage, leaves in rainfall, birds, and, here, a composition of clams, scallops, and plums. The shells lie on a ground devoid of plane or horizon, concentrating attention on their shapes and markings. The composition clusters around the massive architectural scallop shells; their fringed gills reveal that Kiitsu was observing living animals. In this work the subdued colors and geometric shell patterns attain a restrained and elegant sobriety.

NAKABAYASHI CHIKUTŌ
Japan, 1776-1853
Plum Branch, Edo period, 19th century
Hanging scroll, ink on paper;
53¾ × 23¾ in. (136.5×60.3 cm)
Gift of the Frederick R. Weisman Company
M.76.21.2

By the late eighteenth and early nineteenth centuries, the Nanga, or Southern, school of Chinese-style literati painting was well established in Japan. Its patrons were merchants, wealthy farmers, and professional people who enjoyed sharing intellectual and social life among painters and poets and who sometimes also became accomplished in these arts.

Chikutō, generally considered a conservative painter, was among the foremost Japanese Nanga artists. Also a widely published and respected art theorist, he believed that the proper study of painting began with copying Chinese models in order to gain the technical discipline needed to develop an individual style.

Son of a Nagoya doctor, Chikutō grew up in a family accustomed to art patronage and the society of artists. His mentor Kamiya Tenyū, a wealthy Nagoya merchant and collector, introduced the young man to a lifelong study of Chinese paintings as well as to the painter Yamamoto Baiitsu, who became Chikutō's close friend. In 1802 Chikutō moved to Kyoto, there joining the circle of the influential Rai Sanyō, the volatile and brilliant Confucian scholar, calligrapher, poet, and painter.

Plum blossoms, representing spring, endurance, and renewal, are a traditional subject. In this work Chikutō synthesized Chinese with Japanese Nanga style. The realistically rendered branches are enlivened by curving thrusts and tonal gradations. The soft gray background wash is enhanced by the contrast of dark, wet strokes and white blossoms in a flattened space. A decorative patterning animates the composition, relieving it of the orthodoxy Chikutō often practiced in landscape paintings.

OGATA KENZAN
Japan, 1663-1743
Plates of the Twelve Months, Edo period, 18th century
Stoneware with overglaze enamels,
8 × 7 × ½ in. each (20.3 × 17.8 × 1.3 cm)
Purchased with funds provided by the Japanese Business
Association and the Far Eastern Art Council M.84.64.1-12

Ogata Shinsei, who later took the art name Kenzan, was the younger
brother of the famous Ogata Kōrin, an important figure in the Rimpa
school of Japanese painting. Raised among artists in a wealthy and
cultured family, Kenzan took up ceramics in his late twenties, after a
period of literary and scholarly pursuits.

In 1694 Kenzan opened his own pottery at Narutaki. There he experi-
mented with form, design, and glazes, recreating popular Japanese and
foreign ceramics of slightly earlier times. Kenzan's chief involvement in
production was likely managerial, but he painted or inscribed choice
pieces from time to time. By 1712, in financial difficulty, Kenzan moved
the pottery to a workshop district in central Kyoto. There, surrounded
by printers, lacquerers, and armorers, he prospered.

The turning point for Kenzan and for the development of his mature
style came around 1709, with the return of the gifted Kōrin to Kyoto. The
brothers collaborated until Kōrin's death in 1716, Kenzan designing
vessel shapes for Kōrin to paint. Kōrin's devotion to Japanese motifs,
evident in the collaborative pieces, influenced Kenzan's subsequent work.

A group of twelve plates in the museum's collection, with painting and
calligraphy by the same hand, bears both Kenzan's signature and his art
name from his Narutaki years. Birds and flowers signify the seasons and
the twelve months, conventional Japanese motifs drawn from the poetry
of Fujiwara Teika (1162-1241). The plates represent a passage in Ken-
zan's drive to synthesize two-dimensional painting with three-dimensional
ceramics, a goal he eventually achieved in many striking forms.

STORAGE JAR

Japan, Kamakura period, 13th–14th century
Tokoname ware, stoneware with ash glaze;
15½ × 18¾ in. (diam.) (39.4 × 47.6 cm)
Purchased with funds provided by the Museum Associates, the Frederick
R. Weisman Company, and the Far Eastern Art Council M.80.77

Unique because of its long production history and specialized uses,
Tokoname stoneware was first made as a utilitarian, even rustic household
ware. The dispersal of Tokoname ceramics throughout mainland Japan
parallels the spread of Buddhism, and the ware became associated in
particular with the esoteric Shugendō and Tendai sects. In early Buddhist
ritual, sutras (collections of Buddhist precepts) were stored in Tokoname
jars and buried in mounds, sometimes with other ceremonial objects, a
practice extending throughout Japan by 1100. Large jars were also used as
funerary urns.

In the Momoyama and early Edo periods (1568–about 1650) the tea
ceremony became a highly organized ritual and aesthetic preoccupation.
It was practiced by Zen adherents and conducted by tea masters, many of
whom preferred to use simple wares with natural glazes and shapes
evoking nature's forms and textures. Tokoname ware, with its links to
rural life, embodied many of these virtues; later in the Edo period a series
of master potters signed the Tokoname ceramics they produced especially
for use in the tea ceremony.

Coil-built Tokoname ware has bold, assertive forms, spontaneous and
free-flowing ash glaze, and fire marks, caused by exposure in the kiln to
floating ash and open flame. Glaze and clay-body colors vary with oxida-
tion or reduction in firing and the mineral content of clay and ash. The
chestnut-red body with greenish, flowing glaze is a frequent combination.
This pot is unusual, being broader at the shoulders than its overall height.
The straight-rising neck may indicate its use as a storage or shipping jar.

COVERED BOWL WITH FLORAL SCROLLS
Thailand, Sawankoloke, 14th–15th century
Stoneware with underglaze iron, 5½ × 7 in. (diam.) (13.9 × 17.8 cm)
Far Eastern Art Council Fund M.72.39a–b

From the fourteenth to sixteenth centuries Thai ceramics enjoyed brisk production and wide dispersal throughout Southeast Asia. The friendly interaction of the emerging Thai state with China and other Southeast Asian states assured an exchange of goods and technology and aided their success. Trade contact with the hard-bodied, glazed, nonporous wares of China and Vietnam spurred development of indigenous Thai earthenware and stoneware.

Examples of Thai ceramics have survived in burial sites of the Southeast Asian archipelago and in waste heaps of Thai kiln sites and are preserved among temple and heirloom treasures. Recent archaeological discoveries reveal that both Sukhothai and Sawankoloke wares were prominent in the ceramics trade during the fifteenth century. According to textual sources, the kilns at Sawankoloke eventually superseded those at Sukhothai and prospered until the sixteenth century.

Sukhothai potters produced bowls, heavy jars, and roof tiles in a coarse-bodied glazed ware with underpainted dark brown designs. Sawankoloke potters, with a better quality clay, made a variety of small, delicate vessels, antic figurines, containers, and architectural ornaments. Bisqued and glazed, Sawankoloke ware had underglaze iron-black decoration and brown, pearly white monochrome, or green celadon glazes.

This unusually large, mango-shaped covered bowl is a characteristic Thai form; the knob on the lid is also in the form of a group of mangos. The bowl is decorated with iron-black scrolls over gray slip. Its clear glaze, tinged blue where it pools, is typical of Sawankoloke ware.

ARHAT
Korea, Yi dynasty, dated 1562
Hanging scroll, ink and color on silk;
17½ × 11⅛ in. (44.5 × 28.3 cm)
Murray Smith Fund M.84.112

Worship of *arhats*, disciples of Buddha who had attained enlightenment, was observed in China as early as the seventh century. Such worship accompanied the growth of Buddhism in Korea, where it was widely practiced after the eleventh century, and became popular with Zen Buddhism's emphasis on the individual's struggle for enlightenment.

The inscription on this rare and important painting dates it to 1562 and identifies it as the 153rd of a donation of 200 Buddhist icons commissioned by an unnamed queen for the Fragrant Forest Temple to wish an infirm king good health and long life. Most of the donation was destroyed in the Hideyoshi invasions of the 1590s or subsequently lost. Such paintings served as icons to direct prayer and meditation; in addition, they were a form of pious gesture that benefited the donor as well as the person on whose behalf the gift was made.

Beautifully painted, with strong, deft brush strokes and delicate applications of color, this portrayal captures the arhat's expression of rapt concentration. It is executed in a tradition of arhat painting that emphasizes Chinese, rather than Indian, conventions and mannerisms. Chinese influence is apparent in both the composition and details such as the rock, the pine branch, and the arhat's features and long eyebrows. His lean face and chest, framed by the halo of a saint, suggest asceticism and age. His robe is the elaborate patchwork *kesa* of priestly status. Typically Korean is the jagged brushwork of the rock and the fascination with the elaborate patterns and stylized folds of the robe.

INDIAN AND
SOUTHEAST ASIAN ART

TWO ADDORSED TREE DRYADS

India, 50 B.C.-A.D. 25
Sandstone, 24½×16½×7½ in. (62.2×41.9×19 cm)
From the Nasli and Alice Heeramaneck Collection,
Museum Associates Purchase M.85.2.1

The tree spirits, or *yakshis*, of pre-Buddhist animistic religions were assimilated into an early phase of Buddhism in India. Like numerous other spirits associated with water and earth, yakshis were a familiar part of people's lives and survived in later times as regional and household gods. This pair of back-to-back yakshis once served as an end bracket between two arches or lintels of a huge framed gateway to the sacred grounds of the Great Stupa in Sanchi, one of the burial mounds established by the emperor Asoka (272-232 B.C.) throughout his realm to contain Buddha's bodily relics. Sanchi is one of the most important Buddhist sites on the subcontinent, and its carved gateways are of fundamental importance in gaining an understanding of the early history of Indian sculpture. Both sculptural and epigraphical evidence indicate that sometime between 50 B.C. and A.D. 25 the grounds at Sanchi were enlarged and its four gates covered with rich and lively sculpted reliefs depicting Buddha's earthly exploits.

The yakshis, associated with the flower- and fruit-bearing foliage surrounding them, represent fecundity and the close link of woman with nature. They may be connected with a pre-Buddhist rite in which a young girl danced before a tree to ensure its abundant fruiting. The dryads' swaying postures and rounded forms give a pronounced impression of a fleshly human organism. Their large breasts, tiny waists, and gently swelling thighs and pubic areas are revealed through transparent garments. Their weathered faces still convey smiles of pleasure and invitation.

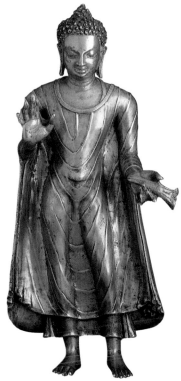

BUDDHA SAKYAMUNI
India, late 6th century
Copper alloy with color, 15½ × 6¾ × 4 in. (39.4 × 17.2 × 10.2 cm)
Gift of the Michael J. Connell Foundation M.70.17

Gupta rule in northern India initiated a long era (320-600) of peace, prosperity, and artistic accomplishment. From the two main artistic centers of the period, Mathura and Sarnath, issued the sculpture now regarded as forming the classical Indian style. This image of the historical Buddha Sakyamuni, with its serene countenance, embodies the Gupta balance of elegant form and inner spirituality.

Although the Gupta rulers were Hindu, they actively patronized Buddhism. Kings and devotees gained spiritual merit by pious acts: building temples, commissioning or making images of Buddha, such as this one, or worshiping them. This Buddha embodies two ideals basic to Buddhism, the perfect yogi and the universal ruler. He possesses the yogi's supple, almost buoyant body and contemplative gaze and facial expression, and the ruler's youth, strong shoulders, firm body, and webbed hands and feet. Time-honored traditions of portrayal connect the Buddha's human form with nature; his long eyes are shaped like fish, his curls like snail shells, and the profile of his left shoulder and arm is like the trunk of an elephant.

This sculpture was probably made in northern India and was influenced by Mathura and Sarnath styles. The image, long preserved in a Tibetan monastery, received there the dark indigo paint on its locks. The striated, schematic folds of the robe were common to Mathura figures, while its transparency, as well as the delicate proportions of face and body and the slight weight shift to the right leg, is reminiscent of Sarnath sculpture.

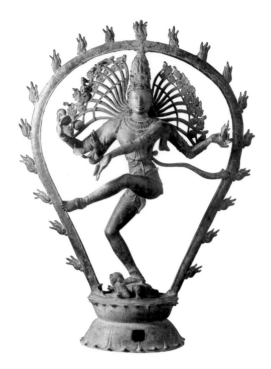

SIVA AS THE LORD OF DANCE (Nataraja)
India, about 950
Copper alloy, 30×22½×7 in. (76.2×57.1×17.8 cm)
Given anonymously M.75.1

Of the three gods of the Hindu trinity — Brahma the Creator, Vishnu the Preserver, and Siva the Destroyer and Restorer — Siva was especially popular and widely worshiped in southern India. This figure has an opening in its base that allowed it to be borne in religious processions, perhaps ornamented and draped.

In India the art of dance is not only regarded as a form of yoga but is associated with the very act of creation. As lord of yoga, Siva is also the source of the cosmic dance that creates the universe in endless rhythmic cycles. The Tamil sculptors of the Chola dynasty (mid-ninth to early fourteenth centuries) realized Siva the Dancer in his most complete and graphic form, one which has become symbolic of Indian civilization.

Siva dances in an aureole of flame that rises from a lotus pedestal, symbol of primordial being and creation. The arched aureole and its three-tongued flames represent the universe and its ultimate destruction by fire. In his upper right hand Siva holds the drum representing the primordial sound at the creation of the universe; the second right hand makes a gesture of reassurance. His upper left hand holds the flame of destruction. The lower one points to his left foot, refuge of the soul, and shows the path of salvation through Siva's trampling of the demon that personifies ignorance.

Siva's body seems to rise and expand with his aureole. The force of his broad shoulders and proud countenance are echoed by the rhythmic explosion of his locks; among them the small figure of Ganges (left) represents the god's intimate connection with water, the force of life. Perfectly poised, this work manifests Siva's divine unity with compelling grace and majesty.

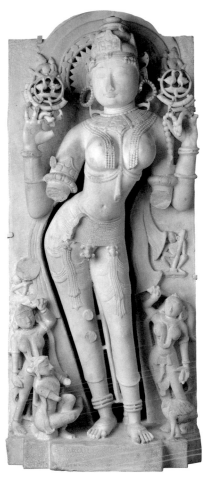

THE GODDESS SARASVATI

India, dated 1153, by Jagaddeva, active about mid-12th century
Marble, 47¼ × 19¾ × 11¾ in. (120.2 × 50.2 × 29.7 cm)
Gift of Anna Bing Arnold M.86.83

Sarasvati, the Jain goddess of knowledge, learning, and music, is iden-
tified in the inscription on the base of this work. It states that the
nobleman Parasuruma commissioned the piece in 1156 from the master
builder Jagadeva to replace one dedicated in a temple in 1069 and
damaged in 1153. Such information is very rare; most Indian sculptures
are anonymous and undated.

The elegant, smooth surfaces and richly carved details of this white
marble figure bespeak the great wealth and prosperity of the Solanki
dynasty (765-1197), when the ports of the state of Gujarat were major
clearinghouses for trade between East and West. Sarasvati originally had
the traditional four arms and in addition to her rosary may have held a
book in one missing hand. The swan, her customary companion, is here
a gander (lower right); facing pairs of geese also appear in the *chakras*,
wheel-like insignias, she holds. Two small deities bearing garlands fly
above them, and at either side of her hips are two more deities, one
playing the *vina*, an ancient instrument, the other playing a flute. Below,
two attendants wield fly whisks, indicating the goddess's high rank; the
donor of the sculpture sits in reverence at her right foot.

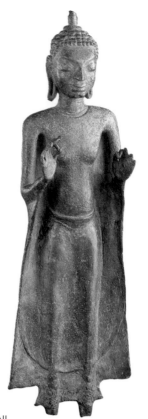

BUDDHA SAKYAMUNI
Thailand, Dvaravati, 8th century
Bronze, 13⅛ × 4 × 2⅛ in. (33.2 × 10.1 × 5.4 cm)
Gift of Mr. and Mrs. Michael Phillips M.84.227.7

In the first through fifth centuries both the Buddhist and Hindu religions spread and flourished throughout the enormous geographical area of Southeast Asia, creating a need for icons to worship. Artists in Thailand, Sri Lanka, Burma, Kampuchea (Cambodia), Indonesia, Laos, and Vietnam used Indian models for their sacred and profane images. Although this common artistic heritage and the adoption of Sanskrit as a court language helped lend unity to these diverse cultures, their religious images evolved into different expressions.

Some of the finest Buddhist images were produced in Thailand in the seventh and eighth centuries, in the era of the Dvaravati kingdom (sixth to eleventh centuries), a culture defined largely by its uniform art style, since it is otherwise known only from a few Chinese references and inscriptions on three surviving Thai medals. At the time the Theravada form of Buddhism prevailed, an essentially monotheistic and monastic religion whose worship focused on the historical Buddha.

This standing bronze Thai Buddha is a classical example of Dvaravati sculpture. It has a characteristically slim, elegant body and swelling limbs and a frontal and symmetrical stance with hands raised in a double gesture of explanation. The serene face has distinctive Mon features. The treatment of the body and transparent garment reveals the influence of Gupta images from Sarnath and perhaps Ajanta, but the symmetry and frontality, not found in these Indian prototypes, are Thai traits.

DURGA SLAYING THE BUFFALO DEMON
Java, 9th-10th century
Volcanic stone, 33×15×5 in.
(83.8×38.1×12.7 cm)
Gift of Anna Bing Arnold M.79.7

The goddess Durga is an aspect of the *magna mater*, the great mother or goddess of Near Eastern cultures, and goes back to paleolithic times. Associated with fecundity and abundance, this goddess entered India with the Indo-Greeks, becoming a cult figure and the subject of many small stone icons in the Kushan period (first to third centuries). By the Gupta era (320-600) Durga was a supreme goddess to her devotees. She embodies *sakti*, the power and energy underlying all of creation.

According to legend, Durga was created by the male gods of the Hindu pantheon, who formed her from the sum of their combined energies for the purpose of defending their tranquility, which was being threatened by the armies of the demon Mahisa. When confronted, Mahisa transformed himself into a buffalo, but Durga was not deceived; she kicked him to his knees, pierced him with her trident, and struck off his head as he tried to resume human form.

Here Mahisa encounters Durga with eight arms and numerous powerful weapons the gods gave her: a conch shell, bow, snake noose, axe, club, and mace. Although Indian representations of this battle are graphic, Javanese depictions are much less lurid. This sculpture lacks Durga's fierce companion and vehicle, the lion, and the buffalo is not mutilated, perhaps in acknowledgment of its essential role in Javanese culture, where it was indispensable in the cultivation of rice. The animal lies almost placidly under Durga's feet. Durga stands serene and graceful in her triumph as the cherubic demon emerges, gesturing with an upraised hand to ward off her wrath.

BUDDHA (detail)
Burma, 13th century
Wood with traces of gilding and polychrome,
60×12×5½ in. (152.4×30.5×14 cm)
Purchased with Harry Lenart Memorial Funds M.84.183

The Burmese temple city of Pagan underwent a spectacular flowering during the eleventh to thirteenth centuries. To embellish the city's numerous brick temples, Buddhist images were created in paint, metal, stone, and wood. Only a small group of figures from Pagan relating to this crowned Buddha survives.

The figure is remarkable for its good condition. Originally lacquered and gilded, its surface still carries traces of lacquer, which no doubt helped preserve it from rot and termites. Its halo of vegetal motifs is almost intact. Only a lower portion of the robe and the lotus pedestal are missing.

The thin, almost abstract rendering of Buddha's body is emphasized by attenuated arms and hands. The lowered hand makes an iconic gesture indicating the granting of a wish, while the raised hand holds the end of his robe or perhaps a sacred text. In marked contrast to the unornamented body, the Buddha's jeweled collar, earrings, crown, tall coiffure, and foliate halo give the image a surprising weight and particularity.

Images of the historical Sakyamuni usually depict a simple mendicant clad in a monk's robe, but this figure's elaborate ornamentation may indicate that it is an idealized portrait of deceased royalty. The kings of Pagan left inscriptions that reveal their expectations of rebirth as Buddhas in the Buddhist heavens; hence this carving may represent a royal ancestor crowned and bejeweled as he was on earth. The apparent interest in individualizing facial features of the group of carved Pagan Buddhas may support this interpretation.

ANDROGYNOUS FORM OF SIVA AND UMA
Nepal, about 1000
Copper alloy with semiprecious stones,
33 × 14½ × 5 in. (83.8 × 36.8 × 12.7 cm)
From the Nasli and Alice Heeramaneck Collection,
Museum Associates Purchase M.82.6.1

One of the earliest of its type known from Nepal, this jeweled representation of the god Siva and his consort Uma depicts them as one being, Ardhanarisvara, The Lord Whose Half Is Woman. The concept of the androgynous image uniting Siva and Uma was devised by theologians to emphasize the nonduality of the divine principle uniting masculinity and femininity. The fact that such images were conceived in a male-dominated civilization reveals the great importance of the feminine principle in Hindu religious thought.

The gods of the Hindu pantheon are considered to be timeless and unaging beings. They are often represented with a lithe, feminine grace, which permitted the artist to join this figure's distinctly male and female halves with minimal disorientation. Uma has a wide hip and prominent breast; Siva is more angular, his waist less sharply curved. His knee-length *dhoti* dips gracefully downward to become Uma's ankle-length garment. His matted locks are piled high in contrast to Uma's elegant coiffure.

Balancing these carefully delineated distinctions, the three surviving arms have similar slender, rounded shapes. A strong vertical ellipse, described by the shoulders, lowered arm, and the sash slung across the lower legs, unites the composition. A second ellipse, suggested by the two raised arms, with its apex at the brow, overlaps and encompasses the first. These circumferences reveal themselves slowly, encouraging an unhurried meditation on the smooth, curved forms and reinforcing the sense of cosmic unity the image is intended to convey. Its sense of calm and balance shows the influence of Indian Gupta art.

TATHAGATA AMITAYUS AND ACOLYTES

Tibet, late 12th century
Opaque watercolors on cloth, 102×69 in. (259.1×175.3 cm)
From the Nasli and Alice Heeramaneck Collection,
Museum Associates Purchase M.84.32.5

In twelfth-century Tibet a flourishing Buddhist religious life was domi-
nated by theistic and faith-centered Tantric observance. It focused on sal-
vation through codified recital of mantras, ritual dances and gestures,
and special meditation. Strict codes also determined color, size, propor-
tion, and formal details of the painted and sculptured images employed at
temples and shrines to aid worship.

This *tanka* (religious painting), one of the oldest and largest preserved
outside Tibet, bears an inscription acknowledging its unusual size and
stating that it was made for the lama Chokyi Gyaltsen (1112-89) for the
life-attainment ceremony honoring the fulfillment of his monk's vows.

The canonically prescribed colors of some of the painting's figures may
have changed or been altered over time. The large central *tathagata*
(manifestation of Buddha) sits on a lotus throne and holds a flower-filled
vase. Through his attributes, gestures, and link with the lama's ceremony,
scholars identify him as Amitayus, tathagata of endless life, although a
green complexion usually indicates a Buddha of healing. He is flanked by
two bodhisattvas (enlightened saintly beings), who stand swaying on
smaller lotuses. The white one is Avalokitesvara, patron of Tibet, and the
brown one, if originally red or golden, would be Maitreya, the future
Buddha. Four bodhisattvas and an apotheosized monk appear on each side
of the tathagata's head. Beneath his throne are three placid bodhisattvas,
Avalokitesvara, Manjusri, and Vajrapani; they are flanked by two fierce
protectors, Hayagriva and Acala. The work is a visualization as well as a
mystical evocation of deities and saints.

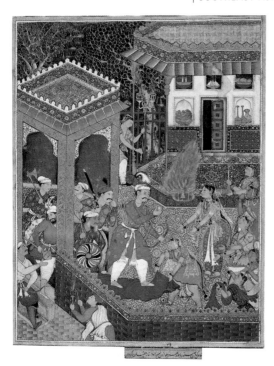

THE HEROES ARE GIVEN REFUGE BY
SENOWBAR BANU AND OMAR
Folio from the *Hamza-nama* (Tales of Hamza)
India, Mughal, about 1562-77
Opaque watercolors on cloth, 30⅞ × 24½ in. (78.5 × 62.3 cm)
From the Nasli and Alice Heeramaneck Collection,
Museum Associates Purchase M. 78.9.1

This scene depicts an episode from an epic whose hero is Hamza, warrior-uncle of the prophet Muhammad. One of a set of 1,400 paintings on cloth, this unusually large illustration was held up to view while the text relating the tale, which is inscribed on the verso of the painting, was recited aloud to a courtly audience.

The *Hamza-nama* was a favorite with Akbar (1542-1605), third Mughal emperor of India and an influential patron of the arts. The twelve volumes of the series were executed in his imperial atelier under the supervision of two Persian painters, Mir Sayyid Ali and Khwaja Abd as-Samad. These artists helped create the Mughal style, a new school of painting incorporating Turkish, Persian, and other painting traditions. Only about 140 works from Akbar's *Hamza-nama* are known to survive.

The painting exhibits Indian style in its attention to the women's postures and the folds of their clothing as well as to the intricate, naturalistic foliage of the tree trunks. The substantial architectural setting is also an Indian preoccupation, although its elements, the portico and pavilion, are Persian, as are the intricately patterned surfaces of wall, floor tiles, and roofs, the three-quarter profiles, and shading. Standard pictorial elements identify warriors, retainers, and attendants. Absence of linear perspective makes a lively contrast with the more naturalistically rendered figures and the foreshortened red carpet. The vertical tilt of courtyard and pavilion conveys the tumultuous entry of the heroes in the foreground, reaffirming the narrative action.

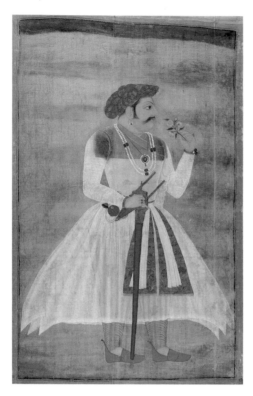

PORTRAIT OF JAGAT SINGH
India, about 1650
Opaque watercolors on cloth, 79¾ × 50½ in. (202.6 × 128.3 cm)
Gift of Mr. and Mrs. Michael Douglas M.85.283.5

The Rajputs, believed to have descended from Scythian invaders of northwest India, formed the source of greatest resistance to the Muslim Mughal conquerors of northern India in the sixteenth and seventeenth centuries. The legendary military valor of the Hindu maharajas (great kings) of the Rajput states was overcome only in 1615, when Amar Singh I of Mewar (r. 1597-1620) accepted nominal Mughal suzerainty. The state of Mewar maintained uneasy relations with the Mughals, but conditions improved during the 1620s. Its Rajput ruler Jagat Singh (r. 1628-54) received gifts and titles from the Mughal emperor Shah Jahan (r. 1628-58), builder of the Taj Mahal.

Traditional Rajput painting consisted mainly of illustrations of poetic themes and religious epics, especially those concerning Krishna, but eventually was influenced by the Mughals' intense preoccupation with historical events and realistic imagery. Rajput painters developed an individualistic portraiture but retained a preference for stereotyped images.

Jagat Singh's pose, with face and legs in profile, shoulders somewhat foreshortened, and fleshy chin, small mouth, and slightly hooked nose are Mughal traits, as is the idea of executing so large a work on cloth. But his smooth expressionless face, as timeless as an icon, and his dark almond-shaped eye are invariable traits of Rajput painting. The precisely poised rose symbolizes the ruler's urbanity, but his great sword, forming an arresting vertical axis, is a reminder that Jagat Singh is also heir to the valiant warrior spirit of his forefathers.

A ROYAL TIGER HUNT
India, 1730-34
Opaque watercolors on paper, 28 ⅞ × 22 ⅝ in. (73.3× 57.5 cm)
Gift of Paul F. Walter M.85.297.3

This work was painted for the Rajput ruler Sangram Singh II (r. 1710-34).
He was the last king to preserve Mewar's internal stability and freedom
from outside interference, even though the state came under nominal
Mughal domination in 1615.

Sangram Singh pursued the pleasures of life that were the ruler's
prerogative, and among them hunting was primary. Pictures of hunts
have been used in many cultures to establish and communicate the
strength and prowess of a ruler. This painting, set in a royal game park,
emphasizes ceremonial aspects of the hunt rather than the drama of the
chase. The landscape seems to represent the hilly terrain just outside
Sangram Singh's palace at the Mewar capital, Udaipur.

The events of the hunt are offered in a panorama beginning (lower
right) with the procession of horses and attendants. Various pauses en
route are shown. The company confers or dines, seated on carpets (left
and center), and stops at a spring (lower center). Eventually they reach
the site of a banquet (center), the visual focus of the work. Above, in
multiple views, a tiger is lured by a dead buffalo and wounded in the fore-
leg before returning by stages to its lair. Sangram Singh and others
observe the tiger's fate from a blind. The ruler appears seven times in the
painting with a nimbus that indicates his divine descent.

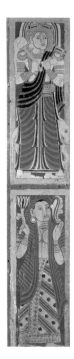
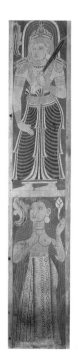

BUDDHIST SHRINE

Sri Lanka, 18th century
Opaque watercolors on wood, most panels approx.
58 × 11½ × ½ in. (147.3 × 29.2 × 1.3 cm)
Gift of Mr. and Mrs. James Coburn III M.79.183.1–27

The preservation of this group of wooden shrine panels decorated with images of gods, guardians, and attendants offers an unusual and intimate link to the ambience in which Buddhist ritual was conducted during Sri Lanka's Kandy era (1597–1815). Various Sinhalese chronicles describe larger and hierarchically more elaborate wooden shrine structures, but the relative simplicity of this edifice has precedent in arts and crafts connected with the Theravada Buddhism of Sri Lanka.

Erected within a monastery complex, this shrine served mainly as a place of ceremony. While flowers, incense, or an image might provide a focus for prayer, the shrine contained no altar, nor was any god worshiped within. Ceremonies of curing, exorcism, or preventing bad luck or demonic mischief commonly transpired at such spots; these particular panels are from a shrine used for the *paritta* ceremony, which was held on the eve of the full moon, when chanting Buddhist monks circumambulated the structure throughout the night in order to gain protection from threatening evil spirits.

The assimilation of Hindu and Buddhist belief is evident in the images, which muster the gods Vishnu, Siva, Ganesha, and Indra alongside Buddhist guardians and attendants. The figures are executed in the bold colors and representational style typical of seventeenth-century Kandyan art. Their hieratic postures make individual figures seem static, but taken as a whole, they convey an unexpected sense of tension and incipient motion. Trapezoidal ceiling panels represent the heavens; their boldly stylized woman-and-foliage motif was a popular element of Kandyan design.

PHOTOGRAPHY

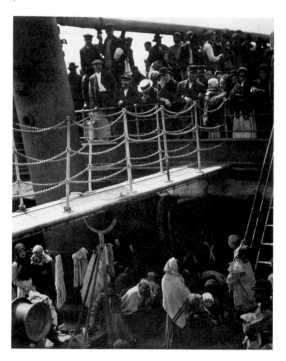

ALFRED STIEGLITZ
United States, 1864–1946
The Steerage, 1907
Photogravure, published in 1915 as a special supplement
to No. 7–8 of *291*; 13⅛ × 10⅜ in. (33.3 × 26.4 cm)
Museum Library Purchase, 1965 NX1 T8

Alfred Stieglitz's impact on photography in the United States was enormous. Born in Hoboken, New Jersey, he spent ten years in Europe gaining an education and recognition as a talented photographer. Upon his return to America he became involved in campaigns promoting photography as a valid artistic medium and was editor of a number of influential journals, including *Camera Work* and *291*. He founded the Photo-Secession, a loose association that included photographers Gertrude Käsebier, Clarence H. White, and Frank Eugene, and organized national exhibitions of photography. In 1905 he founded the 291 Gallery in New York, where he introduced the American public to contemporary European art movements. His ideas profoundly influenced many artists and photographers, including John Marin, Georgia O'Keeffe, Paul Strand, and Ansel Adams.

Stieglitz's photography evolved from atmospheric images of urban life made in the 1880s and 1890s to cubist-influenced compositions in the early years of the century. In the 1920s he began a series called Equiva lents, evocative photographs of clouds and sky meant to convey emotional and intellectual meanings through visual form and tonal range rather than through identifiable and specific subjects.

The Steerage is one of Stieglitz's best-known images and one of the first he made based on his growing sense of photography as an independent medium. It is free of any soft-focus imitation of painted technique. Its powerful geometric opposition of shapes has a clear cubist tendency that marks a turning point in the development of American photography.

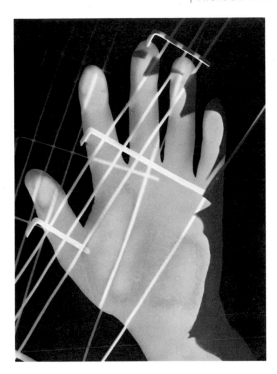

LÁSZLÓ MOHOLY-NAGY
Hungary, 1895–1946, active in the United States
Hand Photogram, about 1925
Gelatin silver print, 9⅜ × 7 in. (23.8 × 17.8 cm)
Ralph M. Parsons Fund M.86.23

A writer, painter, photographer, and teacher, Hungarian-born László Moholy-Nagy touched a broad spectrum of arts, artists, and aesthetic theory with his talents. While still in Europe in the 1920s (he immigrated to the United States in 1937), Moholy sympathized with the goal of dadaist and constructivist artists to erect, by means of industrial and commercial technologies, a new aesthetic on the rubble of outworn bourgeois conventions. Moholy wanted to construct a new perception that would enable man to take the greatest intellectual, spiritual, and aesthetic advantage of the world's emerging technology.

In 1923 the architect Walter Gropius invited Moholy to Weimar to join the faculty of the avant-garde Bauhaus school. There Moholy conducted his first photography experiments, coining the word *photogram* to describe the images he created without a camera, using only projected light and shadows cast by assembled objects upon photographic paper. For Moholy the photogram was a visual analog for *telegram* and carried similar meanings of compressed time and communication.

In the 1920s and 1930s images of the artist's hand proliferated as a constructivist sign, symbolizing among other things the role of the artist's intellect and touch in works that utilized the latest technological advances. Moholy's image was a response to a montage made in 1924 by Russian architect and painter El Lissitzky in which an engineer's compass lies across the artist's extended fingers. Moholy's hand is barely described; it is a shadow alluding to the mysterious presence of the artist rather than delineating the hand as one of many tools.

CLARENCE JOHN LAUGHLIN
United States, 1905-85
The Masks Grow to Us, 1947
Gelatin silver print, 13½ × 10¼ in. (34.3 × 26 cm)
Ralph M. Parsons Fund M.87.82.1

Self-taught in photography and other fields, Clarence John Laughlin studied the French symbolist poets and had strong literary interests. He belonged to no school or coterie of artists and credited his interests in painting, architecture, psychology, and writing with enriching his allusive photography.

Fantasy and enigma are central to Laughlin's work, which gives full rein to surrealism and a sense of otherworldliness. He was an enthusiastic chronicler of American architecture, but even these photographs, with their emphasis on decaying antebellum structures of the South, where Laughlin was born and where he worked, have a dreamlike remoteness. His enigmatic titles enhance the metaphorical quality of his images.

Laughlin's romanticism runs counter to the purist aesthetic of Edward Weston and Ansel Adams, whose work was devoted to capturing the essence of a subject in a photograph, what Weston called "the thing itself." But Laughlin, experimenting with photographic processes, skillfully used montage and sometimes double exposure to undermine the sense of the photograph as an "authoritative" image or an accurate record of temporal reality. The ambiguity of the techniques used to achieve *The Masks Grow to Us* lends an ethereal and unreal quality to the scene. The uncertainty of subject dispels the specificity expected in a photograph; the issues of time, place, and record become irrelevant.

VAL TELBERG
Russia, born 1910, active in the United States
Portrait of a Friend, about 1947
Gelatin silver print, 10 ⅞ × 9 ⅛ in. (27.6 × 23.1 cm)
Ralph M. Parsons Fund M.87/81.1

Born in Russia, Val Telberg lived in Moscow and in Tungchow, China, before coming to the United States in 1928 to complete his education. He studied painting at the Art Students League in New York, where he encountered the work of surrealist artists René Magritte and Salvador Dalí as well as the films of Jean Cocteau and other experimental filmmakers. Telberg supported himself with a number of odd jobs, including a quick developing service for nightclub camera girls, and he later ran a comic-photo concession at an amusement park. This commercial work constituted Telberg's introduction to manipulating photographic processes, but by 1945 he had begun a serious exploration of photography.

Like Clarence John Laughlin, Telberg uses surrealistic practices, such as allowing accidental juxtapositions of found symbols to express intuitive thoughts. But, more than Laughlin, Telberg exploits a sense of unreality by using negative images, solarization, and recombined images. His use in the 1940s of composite printing placed his work outside what was then recognized as photography's mainstream.

Telberg's interest in films, especially the uses of dissolves, has had a profound effect on his work. His photographs, in fact, resemble film footage that has been compressed and collaged rather than left to play out over time. As in *Portrait of a Friend*, narrative images are arranged with abstract elements in a dense and detailed frame, the layers of overlapping, abstract forms obscuring the realistic imagery. The viewer must determine whether the scene moves forward, backward, or both.

EDWARD WESTON
United States, 1886-1958
Dunes, Oceano, 1936
Gelatin silver print, 7½ × 9½ in. (19 × 24.1 cm)
Given anonymously 46.61.2

Edward Weston's very early work was in the impressionistic pictorialist manner, with its romantic subjects, theatrical lighting, and painterly effects, but by the 1920s he was beginning to question both the vitality and validity of this kind of photography. His 1922 visit to Alfred Stieglitz, by then a convert to modernism, confirmed Weston's apostasy. He immediately turned to developing the straightforward and unretouched photography of natural objects and scenes for which he became famous.

From 1923 on, Weston kept journals recording his ideas about work and the events of his life. In them he spoke directly of his aims: "To see the *Thing Itself* is essential: the quintessence revealed direct . . . to photograph a rock and have it look like a rock, but be more than a rock." For Weston making photographs was not merely the creation of factual records or formally beautiful compositions, but communication of the essence of the scene before the camera, which he described as "the greater mystery of things revealed more clearly than the eyes see."

Weston's photographs of shells, peppers, sea wrack, and tide pools of the Carmel coast are among his more renowned studies. His series of photographs of the sand dunes at Oceano exhibits his mastery of landscape photography's challenge: to reveal through balance, precision, and sensitive perception the intricate abstraction inherent in natural forms.

AARON SISKIND
United States, born 1903
Untitled, 1948
Gelatin silver print, 8⅜×13½ in. (21.2×34.3 cm)
Given anonymously M.84.163

Aaron Siskind is best known for his almost painterly photographic abstractions, but he began his career by documenting living conditions among the destitute and homeless in New York City in the early 1930s. Even in this early work there exists a strong sense of composition and almost abstract balance of black and white. In 1940 he began to make photographs of isolated objects in simple arrangements that further articulated his interest in formal relationships. By the mid-1940s, in Martha's Vineyard for an architectural photography project, Siskind was making photographs without reference to identifiable objects. These pictures transcend their subject matter; while obviously grounded in reality, there are few details that give visual clues to scale or shape. The photograph becomes an object with its own integrity rather than a depiction or illustration.

Siskind continued to experiment with this idea and was influenced and encouraged by, and in turn exerted influence on, the abstract expressionist painters Barnett Newman, Willem de Kooning, and Franz Kline. The partial views, close-ups, and isolated details of his photographs take on an existential power much like these painters' canvases in which the surface of the object — the canvas or the photograph — is emphasized. This photograph, made in 1948, has much of the raw feeling of abstract expressionism, while, ironically, communicating an intimate sense of real material. It illustrates Siskind's resolve to "make a photograph . . . an altogether new object, complete and self-contained, whose basic condition is order — unlike the world of events and actions whose permanent condition is disorder."

JOHN GUTMANN
Germany, born 1905, active in the United States
Black Jack at Reno at Election Time, 1936
Gelatin silver print, 9×7⅜ in. (22.9×19.4 cm)
Ralph M. Parsons Fund M.85.194.2

John Gutmann, an expressionist painter in the manner of Die Brücke, arrived in the United States in 1933 to photograph Depression-era America with a Rollei camera for Press-Foto, a German agency. He settled in California and continued to take photographs for the German illustrated weeklies. In the late 1930s he switched to a new press agency, and his work began to be published in American magazines.

Gutmann was fascinated by Eastern urban culture, and his photojournalistic style and subject matter were quite distinct from that of his Californian contemporaries William Mortensen, Imogen Cunningham, and Ansel Adams. Gutmann made a trip across America in 1936, staying several months in New York City before making his way back to the West Coast. Like the Swiss photographer Robert Frank, who twenty years later also made a cross-country odyssey, Gutmann sought ordinary people and events as his subjects and captured the mundane in a way that prompts the observer to insight.

Gutmann always provided captions for his photojournalism assignments and carried this practice over to his own work. *Black Jack at Reno at Election Time*, depicting players as intent as stockbrokers before the chalkboard roster of odds, becomes a more potent image when the ordinary yet insular activity of gambling is juxtaposed with the auspicious event of an election.

ROBERT FRANK
Switzerland, born 1924, active in the United States
Restaurant — U.S. 1 Leaving Columbia, South Carolina, 1955
Gelatin silver print, 11×14 in. (27.9×35.6 cm)
Gift of Ruthe and Philip Feldman M.81.294.11

Swiss-born photographer and filmmaker Robert Frank documented America and American customs from a dispassionate yet highly personal point of view. Traveling across the country in 1955 and 1956 on the first Guggenheim Foundation grant awarded to a photographer, he made pictures with a hand-held camera which were loose in style and radical in subject matter: the sometimes desolate landscape and often disaffected people of prosperous postwar America. The photographs, published in the monograph *The Americans* in Europe in 1958 and in the United States a year later, were widely criticized for being poorly made and for the painful introspection they portrayed. Frank's rhythmic, elliptical, and often primitive style offered a pictorial complement to the radical literary view embodied in beat poetry and fiction. Frank was, in fact, a friend to writers Allen Ginsberg, Gregory Corso, and Peter Orlovsky, and Jack Kerouac wrote the introduction to *The Americans*.

 Frank's photography provided counterpoint to another famous photographic endeavor of the mid-1950s: Edward Steichen's *Family of Man* exhibition at the Museum of Modern Art, which projected and celebrated a utopia of universal brotherhood. Frank's images proved to be far more influential on succeeding generations of photographers, including those who participated in the rise of socially conscious photojournalism in the 1960s. The irony of Frank's observations, seen in images such as *Restaurant — U.S. 1 Leaving Columbia, South Carolina*, in which a TV journalist glows from an unwatched set, was not lost on those conscious of the necessarily voyeuristic role of the photographer.

MINOR WHITE
United States, 1908–76
Windowsill Daydreaming, 1958
From the Jupiter portfolio, 41/75
Gelatin silver print, 13¾ × 10⅝ in. (35 × 27 cm)
Ralph M. Parsons Fund M.84.189.6

Minor White, like Edward Weston, understood photography as an artistic
medium with the potential to do more than merely depict a subject. For
him, even more than for Weston, a photograph had metaphorical and even
transcendental possibilities. As a teacher and as founding editor of the
influential photography magazine *Aperture*, White brought other disci-
plines and philosophical theories to bear on photographic practices and
defined the role of photography during the 1950s and 1960s.

White was affected by Alfred Stieglitz's notion of the "equivalent,"
the idea that photography could function as metaphor rather than illus-
tration. White placed his photographs in sequences to further specify
and articulate an image's meanings. He wrote in the colophon to his
Sequence 4: "While rocks were photographed, the subject of the se-
quence is not rocks; while symbols seem to appear, they are pointers to
the significance. The meaning appears in the spaces between the images,
in the mood they raise in the beholder."

Windowsill Daydreaming appeared in two of White's sequences: the
Jupiter portfolio assembled in 1975, from which this photograph is
taken, and The Sound of One Hand Clapping, a group of photographs
White assembled in 1959 based on his meditation on the Zen koan.
White made this and many similar photographs of the windows in his
apartment in Rochester, New York, over a two-year period.

This image has a magical quality, yet the phenomenon pictured — light
patterning a wall — is rather ordinary. White's mastery of formal relation-
ships and his highly personal, nonnarrative purpose give palpable pres-
ence to a fleeting occurrence.

JOHN PFAHL
United States, born 1939
Triangle, Bermuda, 1975
From the Altered Landscapes portfolio, 22/100
Dye transfer print, 7 ¼ × 9 ⅞ in. (18.4 × 25 cm)
Gift of Barry Lowen M.82.261.1

John Pfahl is a photographer who works completely within the straightforward, documentary tradition of photography, yet his work also defies that tradition. He uses our expectations of photographic truth to demonstrate how "facts" can be manufactured. In the Altered Landscapes portfolio, each image is the result of painstaking technical work on the site to construct ingenious and witty illusions of perspective. In a more recent body of work, Power Places, Pfahl photographed the sites of nuclear power plants in the grand style of nineteenth-century photographers who captured the beauty and monumentality of nature. He thus creates an ironic commentary on the place of such plants in the modern landscape.

For *Triangle, Bermuda* Pfahl stationed his camera in an intertidal zone and drove two pegs into the sand. A cord between them suggests the base of a triangle; its other two legs run into the sea-wash. Pfahl photographed what appeared before his camera, but the objects he recorded are not actually where they appear to be. The monocular camera has compressed space to give the illusion that the rock in the background and the pegs in the foreground really lie in the same plane. The image reads as a string drawing yet also conveys scale and distance, creating a disconcerting shift between simultaneous yet contradictory perceptions of real space.

EILEEN COWIN
United States, born 1947
Untitled (Woman in Red Shirt), 1981
Cibachrome print, 19×24 in. (48.2×61 cm)
Graphic Arts Council Curatorial Discretionary Fund M.84.17

The self-conscious awareness that we live in a camera-based and camera-bound culture marks the so-called postmodernist vein of art and photography that emerged in the early 1980s. This kind of art accepts the world as a place of images, an endless hall of mirrors where images are not only all we can see but also all we can ever know of reality. Concepts of originality and individual artistic vision have little relevance in this world. These are disconcerting and radical ideas, and photography, considered a very nearly indiscriminate producer of images, figures largely in them.

Since 1980 Eileen Cowin has made photographic tableaux that she at one time called "family docudramas." Referring loosely to television soap-opera vignettes, film stills, or even romance comic strips, these elegant photographs represent arranged family situations that imply discord. Cowin uses herself as a foil, at times including her identical twin sister as well as other family members. In a scene such as this, where both twins appear, the two women read as one, embodying the ambiguity of the participant and observer, of reality and fantasy, of anxious ego and critical superego.

In the customary formalized sittings and casual snapshots of family life, conflicts and tensions stemming from envy or dissension are suppressed. In contrast, even though her tableaux are artifices painstakingly mounted in the studio, Cowin's images evoke a sense of confrontation, an arrested and enigmatic interaction that has no single meaning. They assume the emotions, sympathies, and interpretations that the viewer brings to them.

PRINTS AND DRAWINGS

ALBRECHT DÜRER
Germany, 1471-1528
Adam and Eve, 1504
Engraving, 9¾ × 7½ in. (24.8 × 19.1 cm)
Purchased with funds provided by the Art Museum Council M.66.33

Adam and Eve helped establish Albrecht Dürer as one of the undisputed masters of engraving, even in his own day. Dürer's virtuosity is most evident in his use of line. Modeling the figures in light and shade, it varies from coarse, for tree trunks, to very fine, for shading on the legs. The print also exhibits Dürer's fascination with classical canons of beauty and proportion as well as minute descriptions of the natural world.

Adam and Eve are depicted in the moment before the Fall. Eve conceals one apple in her left hand and is about to accept another from Satan in the guise of a snake. This predatory theme is echoed by the cat, tensely crouched to pounce on the mouse between Adam's feet. The parrot, symbol of wisdom, turns its gaze from the impending debacle.

Dürer represented this final moment of man's untarnished state with perfect human figures of mathematically determined proportions. Adam is posed like the *Apollo Belvedere*, the classical sculpture representing the male physical ideal, and Eve is modeled on classical prototypes of Venus.

Naturalism and whimsy carry the narrative to an audience well versed in symbol and imagery and accustomed to their visual interpretation. The cat, elk, rabbit, and ox represent man's four temperaments, or humors, elements found in harmony in the perfectly balanced soul: choler or anger, melancholy, the sanguine or sensuous, and phlegmatic or apathetic. In the distance a goat teetering on a precipice provides a literal image of Adam and Eve's final moment of precarious equilibrium.

BALDUNG GRIEN (Hans Baldung)
Germany, 1484-1545
The Lamentation, about 1515-17
Woodcut, 8⅜×6 in. (21.9×15.3 cm)
Purchased with funds provided by The Ahmanson Foundation,
the Garrett Corporation, Graphic Arts Council Curatorial
Discretionary Fund, and Graphic Arts Council Donors: Mr. Werner
Boeninger, Mr. and Mrs. Philip Meltzer, Mrs. Mary S. Ruiz, Dr. and
Mrs. Richard A. Simms, Dr. and Mrs. Kurt Wagner, Mrs. Estelle
Williams, and Mr. and Mrs. Julius L. Zelman M.85.217

In the first two decades of the sixteenth century woodcut design and
execution attained a virtuosity never since surpassed. Wood's grain and
brittleness impose limitations on fineness, degree of curve, and proximity
of lines. Early woodcut artists acknowledged these constraints with
compositions displaying simple outlines, broad curves, and little model-
ing. By 1500 Albrecht Dürer, Baldung Grien, and their contemporaries
had mastered more advanced techniques. Crosshatching enabled them
to achieve light, shade, and modeling in complex compositions with
sophisticated surface pattern and anatomically correct figures, and under
the impetus of artistic developments in Renaissance Italy, these printmak-
ers began to employ the innovations of foreshortening and perspective
as well as conventions of gesture and costume. Baldung Grien was
especially adept at combining these new methods of depiction with the
traditional northern European fascination with pattern.

The Lamentation alludes forcefully and economically to the Passion
narrative. The site on Calvary is indicated only by three cross standards,
the ladder, and the thieves' feet. In the foreground, spikes and a pot
of unguent refer to Christ's crucifixion, deposition, and entombment.
Christ's body echoes the pose of the crucifixion, and the mourners'
postures convey their grief. Mary Magdalen's raised arms and tumul-
tuous hair form an iconic gesture of despair; John weeps over Christ's
mutilated hand. The Virgin and Christ are sharply foreshortened, display-
ing Baldung's mastery of perspective.

ROSSO FIORENTINO
(Giovanni Battista di Jacopo di Guasparre)
Italy, Florence, 1494-1540
Judith with the Head of Holofernes, about 1538-40
Red chalk, 9⅛×7¾ in. (23.2×19.7 cm)
Dalzell Hatfield Memorial Fund M.77.13

The subject of this drawing was well known in Italy and had special meaning in Rosso Fiorentino's native Florence. Found in the Apocrypha, the story of the slaying of the Assyrian general Holofernes by the Israelite widow Judith is traditionally a parable of the triumph of humility and continence over pride and lust. In the late fifteenth century the Florentines placed Donatello's *Judith and Holofernes* in front of their town hall as a symbol of the qualities they hoped would keep them free from domination by enemies.

Rosso's interpretation of the event is unusual and enigmatic. The nudity of Judith, her servant, and the hapless general, for which there is scarcely precedent either in the story or its traditional depictions, is emphasized by Rosso's use of light and shadow. Judith's classical stance gives her an air of assured competence, allowing Rosso to convey her potent attractiveness in the modeling of her shapely thighs and fleshy lower abdomen. She holds Holofernes' head as effortlessly as she might a fan, her strong heroic arms and pubescent breasts modifying the statement of her sensual lower body.

According to the story Judith remained chaste not only here but for the rest of her life, but Rosso's Judith seems to partake of both virtue and sensuality. The sharp contrast of her youthfulness with the extremely aged woman also makes this work a parable of mortality. This multi-faceted approach to religious subject matter is typical of early mannerist artists, who rebelled against the rational and universal ideals of the High Renaissance by interpreting iconic subjects in unconventional ways.

GIOVANNI BENEDETTO CASTIGLIONE
Italy, about 1610-63/65
St. Mark, about 1655-60
Oil and gouache, 14⅜×9¾ in. (36.5×24.8 cm)
Purchased with funds provided by the Garrett Corporation M.82.73

Giovanni Benedetto Castiglione is renowned as one of the master drafts-
men of Italian baroque art. He perfected a classically ordered style like
Nicholas Poussin's as well as a broad, fully baroque style in the manner of
Peter Paul Rubens and Gian Lorenzo Bernini, artists whose works he
knew. Castiglione also originated a distinctive type of drawing, with oil
pigments on paper, in which he developed an expressive personal style. By
the time Castiglione drew *St. Mark*, his highly individual approach made
his drawings as satisfying as finished works, even though, as here, they
might be studies for paintings.

Castiglione's treatment of Mark writing his Gospel displays the spiri-
tual energy and emotional intensity valued in art of the Counter-Reforma-
tion. For example, Mark is viewed close up, the loosely brushed strokes
conveying a message of faith in unambiguous physical terms. His rapt
upward gaze and smile acknowledge divine inspiration and grace.

The articulation of Mark's head and torso depicts a man physically and
spiritually supported by God's grace. In contrast, the lower portion of the
composition seems vague. The lion often appears in medieval art as the
symbolic transmitter of Mark's inspiration, but here its forceful form is
subdued. Castiglione apparently changed the lion's position from near
Mark's foremost knee to its present place at his side; the unresolved
position of the paws reflects this choice. In its overall effect this vigorous
work combines the spontaneity of drawing and the powerful forms of the
baroque grand manner with Castiglione's singular interpretation of the
ecstatic evangelist.

REMBRANDT HARMENSZ VAN RIJN
Holland, 1606-69
Christ Presented to the People, 1655
Drypoint, 14×17⅞ in. (35.6×45.4 cm)
Mr. and Mrs. Allan C. Balch Collection M.61.3

In 1655 Rembrandt finished the last of eight states of this etching of Christ's judgment. The first five states of the print include a milling crowd in the foreground below the central group. In the sixth state, Rembrandt burnished out this crowd, replacing it with two arches flanking the figure of a river god. As a result, the somber composition, seen here in the seventh state, is organized almost entirely by the prominent architecture separating and enclosing three major groups. The curious townsfolk (left and right) represent disorder; the officials and soldiers around Christ symbolize an abstract, implacable justice. Individual figures are confined to windows, as the carved figures of Justice and Prudence are confined to their niches.

Both this subject and its presentation in an architectural setting had long been popular in northern Europe. The shallow, stagelike composition, with its varied levels and central platform, provided Rembrandt the opportunity to depict a large crowd of people. They are clothed in the anachronistic combination of exotic and contemporary costume that appears frequently in his biblical compositions. The variety of poses and costumes tempers the powerful symmetry of the architecture.

A shadowy central arch frames the richly dressed Pilate, who points to Christ, physically powerless among his oppressors. Rembrandt's very human depiction of the Savior occurs often in his work. The public setting of the judgment connects the image to the contemporary European practice of sentencing convicted persons in the open, before crowds.

HUBERT ROBERT
France, 1733–1808
Landscape with Steps, 1770s
Red chalk, 17½ × 12⅜ in. (44.5 × 32.1 cm)
Gift of Anna Bing Arnold and purchased with funds
provided by Mr. and Mrs. Billy Wilder 86.13

In 1754 the painter Hubert Robert traveled to Italy with the diplomatic mission of Count de Stainville, the French ambassador to Rome. For the next eleven years he studied, painted, and drew the decaying ruins of the monuments of classical antiquity. Robert was strongly influenced by Giovanni Battista Piranesi's architectural drawings and sometimes fanciful reconstructions of Roman buildings. Robert found a responsive audience among his contemporaries, who saw in his depictions of Rome's past grandeur a melancholy but noble perspective from which to contemplate their own mortality.

The artist returned to Paris in 1765 and put his fascination with picturesque ruins to good use. In addition to his career as a painter, he became a landscape designer and by the 1770s was in great demand to construct gardens in the newly fashionable naturalistic manner.

This drawing, done in the red chalk Robert favored, shows a fountain and stairs leading to a formal terrace. The figures establish the scale in this graceful and imaginative setting, where towering trees with arching branches replace the formal symmetry and stonework of traditional baroque gardens. Foliage of varying density is rendered in Robert's rapidly executed sawtooth line and characteristically vigorous and assured hand.

Robert was a forebear of later romantic artists who painted real and imaginary landscapes, and his work marks the progression of the genre from a relatively minor position in academic eighteenth-century art to one of the most important themes in French painting of the nineteenth century.

EUGÈNE DELACROIX
France, 1798-1863
Strolling Players, 1833
Watercolor, 9¾ × 7¼ in. (24.8 × 18.4 cm)
Art Museum Council Fund M.85.126

The Orient exercised a powerful appeal for Eugène Delacroix and many other romantic artists and writers. The sensuality of light-drenched color, dusky women, and exotic locales attracted the romantic taste for heightened sensory and emotional experiences. The painting salons of early to mid nineteenth-century France included subjects associated with the East, ranging from fabulous horses to violent men.

Delacroix's paintings are perhaps the most memorable of this exotic genre. When in 1826 he painted his ambitious *Death of Sardanapalus*, depicting the death of an Assyrian king, he had never traveled outside France. Five years later, however, Delacroix was invited to go to Morocco to record the principal events of a diplomatic mission. Led by Count Charles de Mornay, the group sailed to Tangiers and eventually traveled overland to Meknes. During four months abroad Delacroix filled sketchbooks with what he had witnessed, producing a body of material that he drew upon for the rest of his career. This was the sole journey he ever made to northern Africa.

Delacroix painted this watercolor upon his return to France while temporarily detained in quarantine because of a cholera outbreak. He produced an album of eighteen watercolors as a memento of the expedition for de Mornay, of which this work is one. This scene of strolling players captures both the immediacy and exoticism of Morocco's customs.

JAMES McNEILL WHISTLER
United States, 1834-1903, active in England
Drouet, 1859
Etching and drypoint, 8⅞×6 in. (22.5×15.2 cm)
The Julius L. and Anita Zelman Collection M.86.366.9

James McNeill Whistler is best known for evocative and atmospheric landscapes and for the austere tonal portrait of his mother. Associated with the impressionists, Whistler developed a painting style verging on the abstract, and in many of his paintings the artist's fascination with the play of color and form overwhelms any representational literalness.

Whistler's prints reveal another side of his perception. This etched portrait of the French sculptor Charles Drouet is a telling study of artistic personality as well as a masterful record of appearance. Although Whistler has boldly simplified the body, he observes the details of facial structure and texture closely: the virile beard, the slightly careworn brow, the shadowed eyes.

Born in Lowell, Massachusetts, Whistler, the son of a civil engineer, enjoyed the benefits of private drawing instruction from his youth. This most distinguished of American painters as a young man endured a most undistinguished career as a military officer at West Point, but the experience was partly redeemed by his work there as a draftsman. Apparently Whistler later learned etching during a brief stint with the United States Coast Guard and Geodetic Survey in Washington, D.C. This extremely rare Drouet portrait, one of a very few impressions made before the plate was canceled, is a product of these early experiences: a masterfully drafted image, it is a fine example of the etcher's linear technique.

HILAIRE-GERMAIN-EDGAR DEGAS
France, 1834-1917
Actresses in Their Dressing Rooms, 1879-80
Etching and aquatint, 6¾ × 8½ in. (17.1 × 21.6 cm)
Purchased with funds provided by Mr. and Mrs. John C. Best,
Dr. and Mrs. Donovan Byer, Mr. and Mrs. Billy Wilder, the Garrett
Corporation, and other donors 86.14

Although the product of academic training, Edgar Degas possessed a powerfully modernist outlook. He admired Jean-Auguste-Dominique Ingres (1780-1867) and studied under one of his pupils. In his formative years Degas was a dedicated copyist of Old Masters. Later he exhibited with the impressionists, shared their aesthetic convictions, and was deeply committed to an art that conveyed imaginative truths rather than literal images.

After about 1870 Degas turned from portraiture and history to painting experiences of modern life. Along with many artists of the day, he realized that etching could preserve drawing's spontaneity even while making multiple original works. Living in an age when experimental method and intellectual achievement were synonymous, Degas became deeply involved in innovative printmaking techniques.

This rare print, of actresses in their dressing cubicles preparing for a performance, reveals the theater world Degas knew so well. Aquatint produces textures and tonalities that can be hand-burnished to change effect; this is how Degas achieved his washlike areas of light and shadow. He was fascinated by effects of interior lighting, which here casts a dramatic shadow to indicate the presence of a third woman. This shadow gives continuity to the receding spaces of the composition, indicated in four vertical panels. The women are linked by their experience of life in these dimly lit rooms, an experience Degas subtly conveyed in line and tone.

WINSLOW HOMER
United States, 1836–1910
Return from the Hunt, 1892
Watercolor, 16 × 21 in. (40.6 × 53.3 cm)
Paul Rodman Mabury Collection 39.12.11

This remarkable and fresh watercolor typifies much of Winslow Homer's work and illustrates the contribution of the American school of landscape painters in the late nineteenth century. In contrast to earlier European treatments of nature, Homer's approach is direct, stripped of literary allusion and pretension.

Early in his career Homer visited Paris, something of a ritual journey for young nineteenth-century artists. The effect of this sojourn upon Homer's work was more subtle than upon that of his American contemporaries. The atmospheric effects he learned from the impressionists were tempered by his preference for naturalistic reportage of American subject matter and reinforced over time by the many years he spent as an illustrator for *Harper's Magazine.*

Homer's subject here is a lake in upstate New York, where a hunter is hauling his dog into a boat. The man is probably an Adirondacks guide, a grizzled local figure Homer painted several times. Homer concentrates on a diamond-shaped composition defined laterally by the skiff and the hoofs of the slain deer, vertically by the man and the dog — a sportsman's perspective. His interest is in physical sensation and immediacy; one can almost feel the precarious equilibrium of the boat as the boy tensely crouches to counterbalance the weight of the soaking dog. Homer's subject is uniquely American and of the moment.

HENRI DE TOULOUSE-LAUTREC
France, 1864–1901

La Gitane (The Gypsy), 1900
Lithograph in four colors, 63×25⅝ in. (160×65 cm)
Promised gift of Kurt J. Wagner, M.D., and the
C. Kathleen Wagner Collection L.86.20.51

The poster *La Gitane* is among Henri de Toulouse-Lautrec's most evocative works, as well as one of the rarest. It advertises a never-published play, now lost; its plot can be reconstructed from contemporary reviews that suggest a story line similar to that of Bizet's *Carmen*, with a sinister and melodramatic twist.

The heroine, Rita, is married to her cousin but betrays him with any man who catches her fancy. Among her casual conquests, the Count de Moreuse refuses to be discarded. He abandons his family and follows Rita to Granada, where, while Rita dances, husband and lover fight and die. The heartless Rita is gleeful and vindictive, as Toulouse-Lautrec shows; the play ends as she steps over the fallen men to flee, laughing with her brother-in-law.

Toulouse-Lautrec's composition captures the sinister interaction in bold silhouettes suggesting harsh theatrical lighting as well as back-alley darkness. This compression of detail is characteristic of Lautrec's work. He is credited with causing the reassessment of the poster as an art form. Posters were made and distributed in Paris from the seventeenth century, but only in the nineteenth was this means of advertising widely practiced by painters. Toulouse-Lautrec's posters are notable for their sophisticated and innovative color. His stark compositions frequently emphasize a single foreground figure, a signature of his work. The flat color areas and abstracted shapes strongly reflect influences Toulouse-Lautrec absorbed from Japanese prints he and other contemporary artists studied.

ERICH HECKEL
Germany, 1883-1970
Standing Child, 1910
Color woodcut, 14⅞ × 10⅞ in. (37.7 × 27.6 cm)
The Robert Gore Rifkind Center for German
Expressionist Studies M.82.288.370b

Between 1910 and 1920 the mature phase of German expressionism reflected the enormous social, cultural, and political changes of that decade. The movement's nucleus, Die Brücke (the Bridge), had four founders: Ernst Ludwig Kirchner, Karl Schmidt-Rottluff, Fritz Bleyl, and Erich Heckel. They believed that the empowering role of art could bring about a revolutionary encounter with man's materialism and spirituality in a totally new society. Architecture students and self-taught artists, they were greatly influenced by Vincent van Gogh, Edvard Munch, Paul Gauguin, and Oceanic and African tribal arts.

The German expressionists conducted prolific experiments in the graphic arts, introducing new techniques, vibrant colors, and disturbing, sometimes controversial subject matter in their prints. Woodcuts provided a way to confirm effects later appearing in their canvases: compositional structure, dramatic contrasts of light and color, the flat picture plane.

Erich Heckel first made woodcuts in 1904. While in Dresden, the four Brücke artists used an adolescent girl named Fränzi as a model. The subject of this print, she was regarded as the ideal child of the new society, at once innocent and wise. Although there are traditional elements in this composition — the standing figure, the landscape beyond the window — there is nothing complacent about it. In contrast to her unformed, almost sexless body, the child's strong, crudely drawn face conveys in a minimum of detail an expression implying knowledge beyond her years.

WILLEM DE KOONING
Holland, born 1904, active in the United States
Woman, about 1952
Pastel, pencil, and charcoal; 14⅜×12⅛ in. (36.5×30.8 cm)
Purchased with funds provided by the David E. Bright bequest,
Paul Rosenberg & Company, and Mrs. Lita A. Hazen M.75.7

In the early 1950s Willem de Kooning reinstated figuration in his work with a series of oil paintings and numerous charcoal and pastel drawings of women. His preoccupation with the image lasted most of the decade and at first greatly alarmed both artists and critics, who feared that because of his enormous artistic authority, de Kooning might somehow overturn the precarious acceptance he and other artists had struggled to obtain for abstract painting in the United States.

But de Kooning had no intention of renouncing his commitment to abstraction. His images of women are indisputably raw, even crude, and relate to his long-standing preoccupation with woman as mother-goddess-fury. He later explained that he had deliberately used the image as a convenient theme that would free him to explore other problems of painting involving connections among the female figure, landscape, and abstraction.

This drawing is among the strongest of the period. Similarly wild, energized strokes characterize de Kooning's paintings; here the woman appears tightly compressed because of her placement in the space yet retains an elusiveness that goes beyond liberties taken with delineation and scale. The ovoid, overlapping shapes of buttocks, breasts, and knees achieve what de Kooning calls "intimate proportions." Limbs and torso parts disorientingly retreat and advance, heightening the image's forcefulness. The angular, boxlike head is unique to this drawing.

TWENTIETH-CENTURY ART

PABLO PICASSO
Spain, 1881–1973, active in France
Portrait of Sebastian Juñer Vidal, 1903
Oil on canvas, 49¾ × 37 in. (126.4 × 94 cm)
David E. Bright bequest M.67.25.18

In 1897 Pablo Picasso interrupted his training at the conservative Royal Academy of Madrid and returned to Barcelona, then the most artistically avant-garde city in Spain, with close cultural ties to Paris. During the next few years Picasso was part of the artistic bohemia of both Barcelona and Paris. At this time he developed his first distinctive style, the Blue Period (1901–4), while preoccupied with questions about the meaning of art. He believed that artistic expression should be unhampered by intellectual constructs and equated an artist's sincerity with his sensitivity to the tragic qualities of life. Picasso depicted forlorn social outcasts, abstracted and isolated in an almost monochromatic blue environment.

Early in 1902 Picasso turned to a more intense investigation of individuals; his works at this time include many portraits. His depiction of his friend Sebastian Juñer Vidal, also an artist, is executed in strong, simplified shapes and forceful brushwork. Picasso's awareness of Cézanne's carefully and ambiguously structured compositions and El Greco's expressive distortions of form emerges here in the development of the spatial relationships of the wall and table, both inextricable from Juñer's strong frontal pose. By contrast, Juñer's companion, painted loosely and rapidly, appears considerably less substantial. Juñer's assertive solidity and direct gaze convey both resolution and reflection, while the woman's eyes are vacant. Picasso seems to have accorded his friend an expression of the same serious, purposeful searching that marked his own early career.

GEORGES BRAQUE
France, 1882-1963
Still Life with Violin, 1914
Oil on canvas, 36½ × 26 in. (92.7 × 66 cm)
Purchased with funds provided by the Mr. and Mrs. George Gard
De Sylva Collection and the Copley Foundation M.86.128

Although Georges Braque trained as an interior decorator and received his craftsman's diploma in Paris in 1901, he soon turned to painting, influenced first by Corot and other landscape artists and then by his contemporaries, the fauves. He was attracted by their shocking colors, but as his early work shows, a preoccupation with form and structure was more basic to his nature.

In 1907 Braque's palette became subdued, and he began to paint landscapes in geometric patterns. By 1908 he and his friend Pablo Picasso were well on their way to developing analytical cubism. This radical pictorial language treated subjects viewed close at hand and from multiple points of view; objects emerged as faceted planes. Minimal color — mostly tones of gray and brown — allows the viewer to concentrate on the rhythmically structured composition that is the true subject of the work.

When Braque painted *Still Life with Violin*, he was moving into a new phase of cubism. He had reintroduced color through bits of paper, which assert the tactile surface of the painting. But here the painted wallpaper (left) and the painted board (center) achieve a trompe l'oeil effect, a skill Braque had learned during his early training. Together with the stencil lettering and the black rectangle, they affirm the painting's surface and relate to the violin shapes and the suggestion of a face below them. Surface quality, illusion, and composition balance in a gentle interaction that recalls the contrapuntal interweaving of a fugue.

WASSILY KANDINSKY
Russia, 1866–1944, active in Germany and France
Untitled Improvisation III, 1914
Oil on cardboard, 25⅝ × 19¾ in. (65 × 50.2 cm)
Museum acquisition by exchange from the David E. Bright bequest
M.85.151

Russian-born Wassily Kandinsky began his career in Munich, where he founded and led the avant-garde artists' group Der Blaue Reiter (the Blue Rider). He developed the first systematic approach to nonobjective abstract painting and from 1910 on abandoned representation altogether. In his book *Concerning the Spiritual in Art*, he rejected the values of the pragmatic age in which he lived, calling instead for an expression of the inner spiritual life in nonliteral terms. "The relationships in art," he wrote, "are not necessarily ones of outward form but are founded on inner sympathy of meaning. . . . Form is the outward expression of this inner meaning." Kandinsky hoped that the power of painting to manifest spiritual imperatives would cast out the last vestiges of the nineteenth century's obsession with destructive materialistic values.

Kandinsky often used musical metaphors to describe his work and had specific associations for color. Yellow was assertive, positive; blue was heavenly, restful; green was passive and smug, like the middle class. White was the higher world, full of silence and possibility; black was silence without hope.

Untitled Improvisation III has changes of scale and shapes that recall Kandinsky's earlier landscapes, but now wiry strips and massed areas float and twist through a colored, energized space. Murky and inert green masses are pierced and enlivened by sharp strokes of intense blue and white. Kandinsky's forms were intended to speak directly to the senses, their meaning reverberating in each soul according to how they are perceived.

KURT SCHWITTERS
Germany, 1887–1948
Construction for Noble Ladies, 1919
Cardboard, wood, metal, and paint; 40½×33 in. (102.9×83.8 cm)
Purchased with funds provided by Mr. and Mrs. Norton Simon, the
Junior Arts Council, Mr. and Mrs. Frederick R. Weisman, Mr. and Mrs.
Taft Schreiber, Hans de Schulthess, Mr. and Mrs. Edwin Janss, and Mr.
and Mrs. Gifford Phillips M.62.22

The dada movement began in Zurich in 1916 with a group of young
artist-intellectuals disgusted with World War I and the constricting bour-
geois values they felt it reflected. Advocates of action, direct involvement
with the present, and the abandonment of traditional values, they were for
the most part nihilists. They experimented with abstract art, nonsense
literature, and *bruitism* (noise concerts); the group eventually had artistic,
literary, and political factions.

Not really a nihilist or activist, Kurt Schwitters was never entirely at
home with dada, and the more zealous dadaists attacked him for his
primary strength, the purity of his artistic purpose. But he shared with
them a fascination with disparate pictorial elements and the rebellious
assertion that the materials of art were not esoteric but close at hand,
even commonplace.

Toward the end of 1918 Schwitters began to work in collage and
assemblage. Cubist collage often incorporated paper or fabric in painting,
but Schwitters started with the objects themselves; where he did use
paint, it was of secondary importance.

Each object in *Construction for Noble Ladies* is carefully placed in
relation to the others yet keeps its own identity. Schwitters had a keen
sense of material as well as of the form and character of each piece of junk
in the vast collection he maintained for his compositions. He believed the
objects' former places in human life imbued them with a status appropri-
ate for art, making them equally or more valid than oil paint or marble.

ERNST LUDWIG KIRCHNER
Germany, 1880-1938
Two Women, 1911/22
Oil on canvas, 59×47 in. (149.9×119.4 cm)
Gift of B. Gerald Cantor 60.33

Ernst Ludwig Kirchner considered himself to be the leader of Die Brücke
(the Bridge), those German painters who rejected late impressionism to
seek a more direct mode of expression. Inspired by his study of Dürer
prints and of Rembrandt drawings, Kirchner sought to capture form and
arrest movement in a few bold strokes. The simplicity of Jugendstil
woodcuts and the power of shape and color in the post-impressionist
paintings of Vincent van Gogh and Paul Gauguin also influenced him.
He always painted from the world around him but with imagination and
inspiration. By 1911, just when Wassily Kandinsky was trying to free
art from prior traditions, Kirchner was investigating Indian and Egyptian
art as well as West African styles.

Kirchner devoted much energy to understanding and recording his
reactions to city life, which both attracted and appalled him. His painting
of two women, perhaps his wife and a friend, is more sympathetic than
many of his street scenes. Nevertheless the two are portrayed as shop girls
typical of the legions that inhabited the early twentieth-century city.
Standing together but not communicating, with feet firmly planted, they
prepare to negotiate the vicissitudes of urban life. Their forms and angled
stances are reflected in the round and zigzag shapes in the background; at
right a standard rises like a tensely extended arm and hand.

The interaction of the strongly formulated shapes of the background
and floor with the simplified forms of the women gives a strange aura to a
commonplace outing, an expressive quality typical of Kirchner's intense
response to life and his artistic transcription of it.

HENRI MATISSE
France, 1869-1954
Tea, 1919
Oil on canvas, 55×83 in. (139.7×210.8 cm)
Bequest of David L. Loew in memory of his father, Marcus Loew
M.74.52.2

Henri Matisse rejected a career as a law clerk to study painting in Paris, where, influenced by the post-impressionist painters, he soon abandoned the academic approach to art. By 1904 Matisse and his friends had been dubbed *les fauves* (the wild beasts) because of their eccentric use of intense color. The movement was short-lived (1904-8), but Matisse continued to paint the flat surfaces of his architectonic canvases with disciplined juxtapositions of color and pattern, depicting only essential details.

By 1919 Matisse had reintroduced foreshortening and spatial effects in his work, experimenting with light in a manner reminiscent of impressionist or symbolist painters but within the unity of his own style. This charming scene at Matisse's home at Issy-les-Moulineaux includes his daughter, Marguerite, his model, Henriette, and his dog, Lili. Every inch of the painting carries expressive content; each color area conditions the effect of all. Casual-seeming splotches of color, irregular forms, and obvious brushwork lend a sense of spontaneity, yet the effect of the dark green shadow around Henriette's chair (right) against a lighter green lawn creates an intriguing and deliberate indistinctness. The model's nearly cubistic features and the distortions of scale in the composition reveal Matisse's wit about painterly matters. The gray-violets of the path, rose-pink spots of light, and subtle greens of foliage are foils for these visual, humorous contradictions and the sense of delight that pervades the painting.

Ceci n'est pas une pipe.

RENÉ MAGRITTE
Belgium, 1898-1967
The Treachery of Images (Ceci n'est pas une pipe), about 1928-29
Oil on canvas, 25⅜×37 in. (64.5×94 cm)
Purchased with funds provided by the Mr. and Mrs.
William Preston Harrison Collection 78.7

The Belgian surrealist René Magritte was not so much interested in the subconscious or dream images as in challenging assumptions about the reality of experience. Magritte judged himself to be a thinker who just happened to express himself in paint. Possessed of an acute sense of the absurd, he did not consider his painting to be symbolic on any level. He presented objects in paradoxical ways, eliminating their normal associations and disrupting visual expectations, causing the mind to shift to unfamiliar territory.

Magritte's painting of an object clearly recalling a pipe is inscribed *Ceci n'est pas une pipe* (This is not a pipe), and he uses traditional Western conventions of highlighting and foreshortening to convey a sense of the three-dimensionality and texture of this commonplace object. Yet the pipe lacks context: it is huge within the format of the painting; there is no man to smoke it, no desk for it to rest on. In one sense the inscription is true: it is only a representation of a pipe, not a pipe itself. In another sense, it is false: the inscription and object are related, each paradoxically denying the other while affirming itself.

Magritte's paintings demonstrate his philosophical absorption with the arbitrary conventions of language and representation. They open up realms of perception that even while encompassing familiar elements of the empirical world manage to liberate the viewer from the limitations of commonplace interpretation.

DAVID SMITH
United States, 1906-65
Cubi XXIII, 1964
Stainless steel, 76¼ × 172⅞ in. (193.7 × 439.1 cm)
Modern and Contemporary Art Council Fund M.67.26

In many ways David Smith's Cubi sculptures of the early 1960s represent the resolution of a restless search artists had begun in the 1930s and 1940s. They were trying to break away from a European sculptural idiom, to go beyond its preoccupation with iconic images, carving, and the mass of solid, cast forms. Some artists turned to biomorphic forms, while others developed minimal ones of welded metal, almost like drawings. Smith, influenced by cubism, Picasso's constructions, and Julio González's welded sculpture, became fascinated with geometric, boxlike forms. They offered the challenge of working with real rather than implied volumes, the possibility of attaining monumentality, and the potential for gesture.

The stainless steel cubes, cylinders, rectangles, and cushion forms of the Cubi series offered limitless combinations while preserving visual references from piece to piece. In his early Cubi sculptures Smith stacked the forms vertically, often atop tall cylinders and always on large bases. He freed many of the later Cubis from the base, that last bastion of traditional sculpture. *Cubi XXIII*, with its horizontally extended composition, possesses an open, energetic, striding motion.

David Smith described his involvement with the Cubi series in spare and simple words: "I make them and I polish them in such a way that on a dull day they take on the dull blue, or the color of the sky in the late afternoon sun, the glow, golden like the rays, the colors of nature. . . . They reflect the colors. They are designed for outdoors."

MARK ROTHKO
Latvia, 1903–70, active in the United States
White Center, 1957
Oil on canvas, 84×72 in. (213.4×182.9 cm)
David E. Bright bequest M.67.25.21

Mark Rothko is among the most profound and popular of twentieth-century artists. He came to the United States in 1913 at age ten, later studied briefly at Yale, and by 1925 was living and working in New York. In the 1920s Rothko was closely associated with the colorist Milton Avery; during the 1930s he knew Adolph Gottlieb, Barnett Newman, William Baziotes, and other artists who later became abstract expressionists. The figuration of Rothko's early work reveals Avery's influence as well as social realist concerns of the time and, by the 1940s, an involvement with surrealism and the mythic, organic forms of tribal art.

By the end of the 1940s Rothko, having rejected restrictions of geometric abstraction as well as the literary allusion and figuration of surrealism, arrived at the color-field painting of his mature style. Wanting to open painting to new kinds of association, he tried to strip his work of extraneous detail. Rothko admired the astonishing atmospheric effects Joseph M. W. Turner had achieved, but his own deepening involvement with color and light went far beyond technical virtuosity. Rothko thought of painting as a "mystical inner construction" and color as "the doorway to another reality." Color alone could subsume formal qualities of area, plane, and volume as well as numinous ones of emotion, mood, and content. Termed "silent painting" and "disembodied chromatic sensation," Rothko's shimmering canvases imply an irreducible spiritual unity.

Rothko valued the color red above all others, perhaps because of its association with the elemental values of fire and blood. *White Center*, like many other Rothko paintings, seems to have its own inner light. Its red areas float or swell and recede like mists, the hazy-edged white rectangle offering a visual focus for the meditative attitude that Rothko's painting demands of the viewer.

DAVID HOCKNEY
England, born 1937, active in the United States
Mulholland Drive: The Road to the Studio, 1980
Acrylic on canvas, 86×243 in. (218.4×617.2 cm)
Purchased with funds provided by the F. Patrick Burns bequest M.83.35
Copyright © 1980 by David Hockney

David Hockney spent much of the 1970s designing and painting stage sets for productions ranging from Mozart's *Magic Flute* (performed at the Glyndbourne Festival, 1978) to three Stravinsky works (presented by the Metropolitan Opera, 1981). Influenced by stage design and by his response to Pablo Picasso's great retrospective exhibition at the Museum of Modern Art, New York, in 1980 Hockney worked in London on a number of freely painted canvases on themes of music and dance.

Returning to his California studio that autumn, Hockney re-examined an unfinished panoramic painting, *Santa Monica Boulevard*, intending to develop in it the flow and motion of his London works. Instead he discarded it as being both too static and too fragmented to achieve his aim: to make the eye traverse a painting as if the viewer were walking, distracted by images, pausing but still moving. Hockney then began to explore motion and panorama in several other works, laying the ground-work for his monumental *Mulholland Drive: The Road to the Studio*,

which he painted from memory during three weeks of November 1980. Hockney drove this quintessentially Southern Californian road daily between his house and studio. It winds ribbonlike along the tops of the hills, appearing almost like a horizon line in the painting. Below it, perspectives of groves, trees, fields, houses, and the planes of tennis courts shift and tilt, as if seen from the window of a moving car. Above the road the painting is divided by two schematic street diagrams, Studio City (left) and Burbank (right), the latter rendered in light lines on a dark ground, an impression gained from seeing this view under night illumination. The painting assimilates Hockney's ideas about the color of Vincent van Gogh and Henri Matisse, Picasso's spontaneity, and the flow of Chinese landscape, all in a joyous union of movement and color.

RICHARD DIEBENKORN
United States, born 1922
Ocean Park Series No. 49, 1972
Oil on canvas, 93×81 in. (236.2×205.7 cm)
Purchased with funds provided by Paul Rosenberg & Company,
Mrs. Lita A. Hazen, and the David E. Bright bequest M.73.96

During the late 1940s and early 1950s Richard Diebenkorn associated with Elmer Bischoff, David Park, and other young San Francisco artists whose innovative abstract expressionist paintings reflected the restless energy of the years after World War II. Yet, by the mid-1950s, Park, Bischoff, and Diebenkorn had each turned to representation, a reversal symbolized by Park's abrupt destruction of his abstract works late in 1949: one afternoon he jettisoned all of them at the Berkeley city dump.

At the time this switch of polarity seemed both retrogressive and shocking; in fact it was part of a more general postwar revival of figuration. Yet each of the three painters remained preoccupied with the flat plane, tension between colors, and viscous surfaces of abstraction. Diebenkorn continued to explore these elements in low California cityscapes, terraces and rooms, and beach vistas that attested his long study of Henri Matisse's interior scenes and landscapes.

Diebenkorn acknowledges a fascination with natural landscape forms seen from the air and the passages of tilling, planting, harvesting, and erosion. All this emerges in the Ocean Park series, which marked his return to abstract painting shortly after he moved from the San Francisco Bay Area to Los Angeles in 1965.

The Ocean Park paintings, about 140 in number, are generally tall canvases composed in variations of vertical and horizontal bars appearing over or under thin, washy panels of color. Like the plow's course through the fields of an aerial landscape, Diebenkorn's tracks remain in his paintings. He paints out, paints over, looks again, guided by the revelations the act of painting unfolds before him.

FRANK STELLA
United States, born 1936
St. Michael's Counterguard, from the Malta series, 1984
Mixed media on aluminum and fiberglass honeycomb,
156×135×108 in. (396.2×342.9×274.3 cm)
Gift of Anna Bing Arnold M.84.150

Among the first of the generation of artists who reacted against the loose
and spontaneous gestural painting of abstract expressionism, Frank Stella
proposed an art of rationality and control. In his radical and controversial
stripe paintings of the late 1950s, Stella denied illusory space in support
of his contention that "only what can be seen there is there." With these
works Stella began a campaign to redefine paintings as objects. He went
on to emphasize this distinction with a series of architectonic canvases,
and by the 1970s he was constructing relieflike paintings, assembling
flat, advancing and retreating shapes in irregular compositions of multi-
ple painted elements. He began to produce looser and more animated
compositions, no longer insisting on the flat, undifferentiated surface of
earlier works.

Through these changes in his style Stella has carried on an intellectual
and aesthetic engagement with the nature of painting. *St. Michael's
Counterguard* exemplifies his recent challenge to the time-honored aca-
demic distinction between painting and sculpture. With this challenge
comes an involvement with depth and volume. This work takes leave of
the wall altogether, breaking through the picture plane, and relies more
on bold, interpenetrating shapes than on a varied palette, although it
retains the compositional elements and patterning of painting.

ANSELM KIEFER
Germany, born 1945
The Book (Das Buch), 1985
Lead, steel, and tin; 114 × 213½ × 34 in. (289.6 × 542.3 × 86.4 cm)
Modern and Contemporary Art Council Fund
and Louise and Harold Held M.85.376

Anselm Kiefer is perhaps the most famous and influential artist working in Germany today. Part of that country's intense, expressive artistic history, his art challenges traditional German ideals, such as the notion of Teutonic cultural superiority, and the apparent concerns of modern art. Kiefer's painting and theater productions frequently deprecate well-known personages and events of Germany's past, and he emphasizes the desolation produced by the exercise of power. Some commentators feel he is intent on replacing a Germanic cultural-political ideology with a new, more universal and humane ideal.

Kiefer relies on symbolism and historical content in his work to establish its social relevance, to make it an eloquent and persuasive expression of serious values. Wings are one of his few recurring positive symbols; he has created works with winged angels and a palette flying on eagle's wings, an image referring to creative inspiration as a means to a new and better existence. But Kiefer's wings are also associated with Icarus of Greek mythology, who fell to his death when the sun melted the wax with which his wings were fastened. Hence this complex image contains both the power of desire and the risk of failure.

The Book incorporates a monumental span of wings and another of Kiefer's symbols, the book. Here it acts as meaning borne aloft on the wings of inspiration, yet the iconic image is rough and inseparable from a sense of laboriousness. The lead surface is also metaphorically significant; heavy and antithetical to flight, this metal figured largely in medieval alchemists' attempts to turn base elements into gold. Every aspect of this work, including its great size, conveys Kiefer's acute and tormented aspirations.

INDEX OF ARTISTS

PUBLICATIONS ON THE COLLECTION

Publishing its permanent collection is one of the chief responsibilities of a museum. The Los Angeles County Museum of Art maintains an active publishing program. We hope that readers of this handbook, scholars, and museum visitors in general will want to learn more about the objects in the museum's collection. Following is a list of current and forthcoming titles. All are or will soon be available in the museum shop or by mail order to Museum Shop, Los Angeles County Museum of Art, 5905 Wilshire Boulevard, Los Angeles, California 90036.

AMERICAN ART
American Art: A Catalogue of the Los Angeles County Museum of Art Collection, Michael Quick and Ilene Fort, to be published 1989

ANCIENT AND ISLAMIC ART
Ancient Bronzes, Ceramics, and Seals, P. R. S. Moorey et al., 1981
Sculpture of Ancient West Mexico, rev. ed., Michael Kan et al., to be published 1989

COSTUMES AND TEXTILES
Dressed for the Country: 1860-1900, Evelyn Ackerman, 1984
An Elegant Art: Fashion & Fantasy in the Eighteenth Century, Edward Maeder et al., 1983

DECORATIVE ARTS
The Art of Mosaics: Selections from the Gilbert Collection, Alvar Gonzalez-Palacios et al., 1982
The Gilbert Collection of Gold and Silver, Timothy Schroder, 1988
Contemporary Ceramics, Martha Drexler Lynn, to be published 1989

EUROPEAN PAINTING AND SCULPTURE
European Painting and Sculpture in the Los Angeles County Museum of Art, Scott Schaefer et al., 1987

FAR EASTERN ART
The Great Bronze Age: A Symposium, George Kuwayama, 1983
Masterpieces from the Shin'enkan Collection: Japanese Painting of the Edo Period, Robert T. Singer et al., 1986

INDIAN AND SOUTHEAST ASIAN ART
The museum is midway through publication of an eight-volume series of catalogues of its Indian and Southeast Asian collection. Four volumes are in print with the remaining volumes (on Indian painting, Indian decorative arts, and the arts of Sri Lanka and Southeast Asia) due for completion by 1993.
Art of Nepal: A Catalogue of the Los Angeles County Museum of Art Collection, Pratapaditya Pal, 1985
Art of Tibet: A Catalogue of the Los Angeles County Museum of Art Collection, Pratapaditya Pal, 1983
Indian Sculpture: A Catalogue of the Los Angeles County Museum of Art Collection, vols. 1 and 2, Pratapaditya Pal, 1986 and 1988

PRINTS AND DRAWINGS
In Honor of Ebria Feinblatt, Curator of Prints and Drawings, 1947-1985, Bruce Davis, 1984
Prints by Erich Heckel and Karl Schmidt-Rotluff: A Centenary Celebration, Gunther Thiem, 1985
German Expressionist Prints and Drawings: A Catalogue of the Collection of the Robert Gore Rifkind Center for German Expressionist Studies of the Los Angeles County Museum of Art, Bruce Davis, 1988
Toulouse-Lautrec and His Contemporaries: Posters of the Belle Epoque, Ebria Feinblatt and Bruce Davis, 1985

TWENTIETH-CENTURY ART
The Robert O. Anderson Building, Earl A. Powell III et al., 1987

Edited by Suzanne Kotz
Designed by Ed Marquand

Text set by Eclipse Typography, Seattle, Washington
Printed by Nissha Printing Co., Ltd., Kyoto, Japan